The Vienna Prater

The Vienna Prater
A Place for Everyone

Werner Michael Schwarz
Susanne Winkler

wien museum

Birkhäuser
Basel

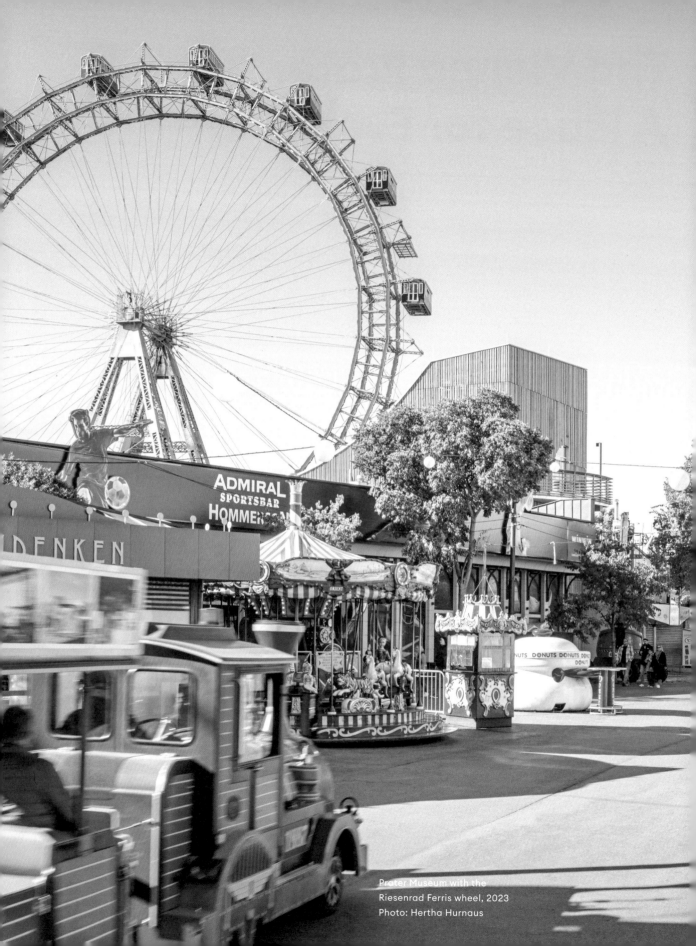

Prater Museum with the
Riesenrad Ferris wheel, 2023
Photo: Hertha Hurnaus

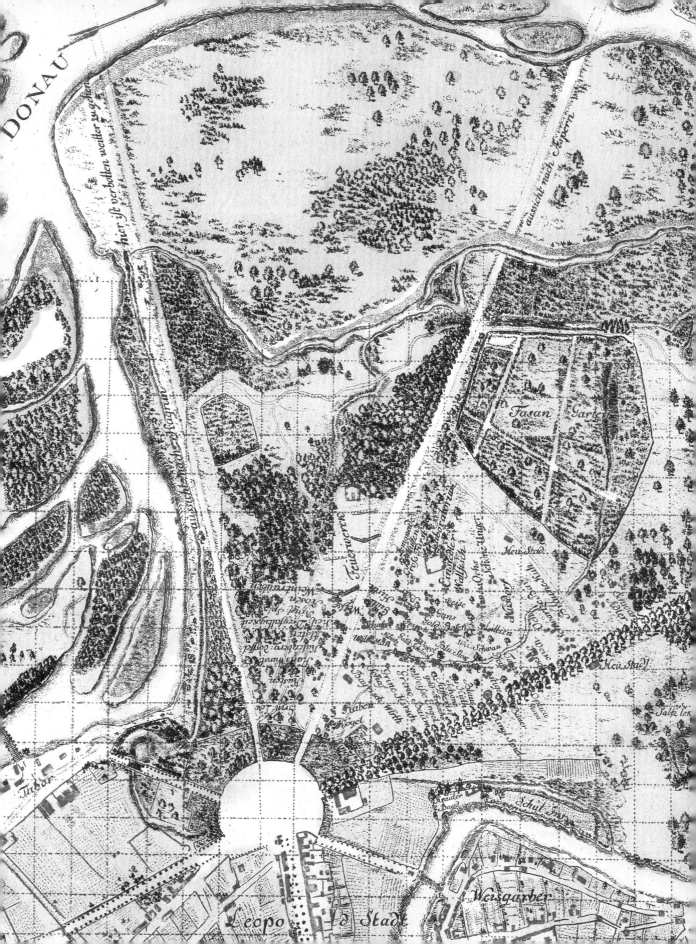

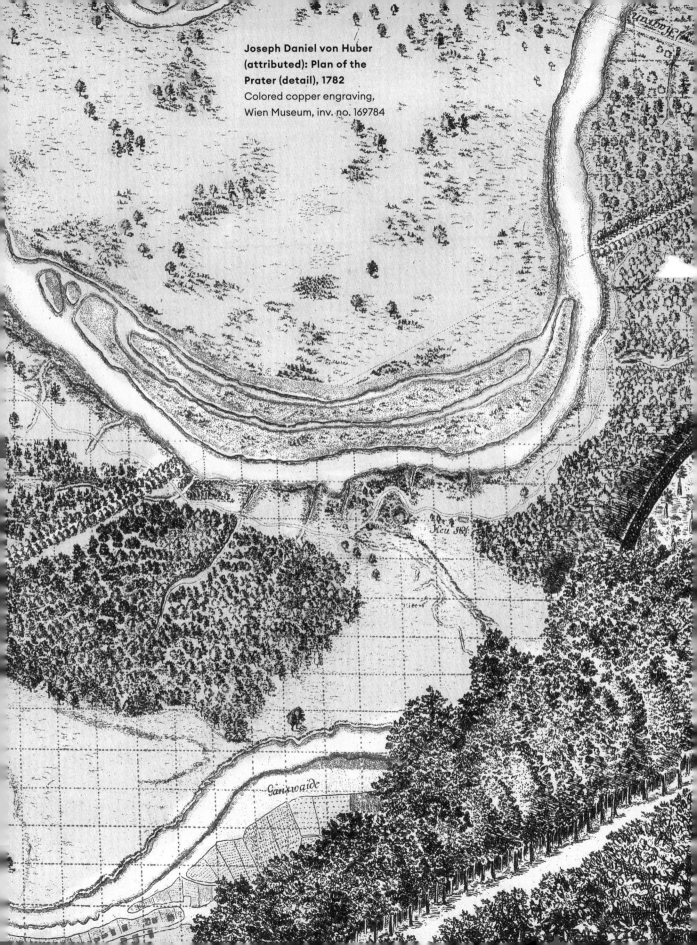

Joseph Daniel von Huber
(attributed): **Plan of the
Prater** (detail), 1782
Colored copper engraving,
Wien Museum, inv. no. 169784

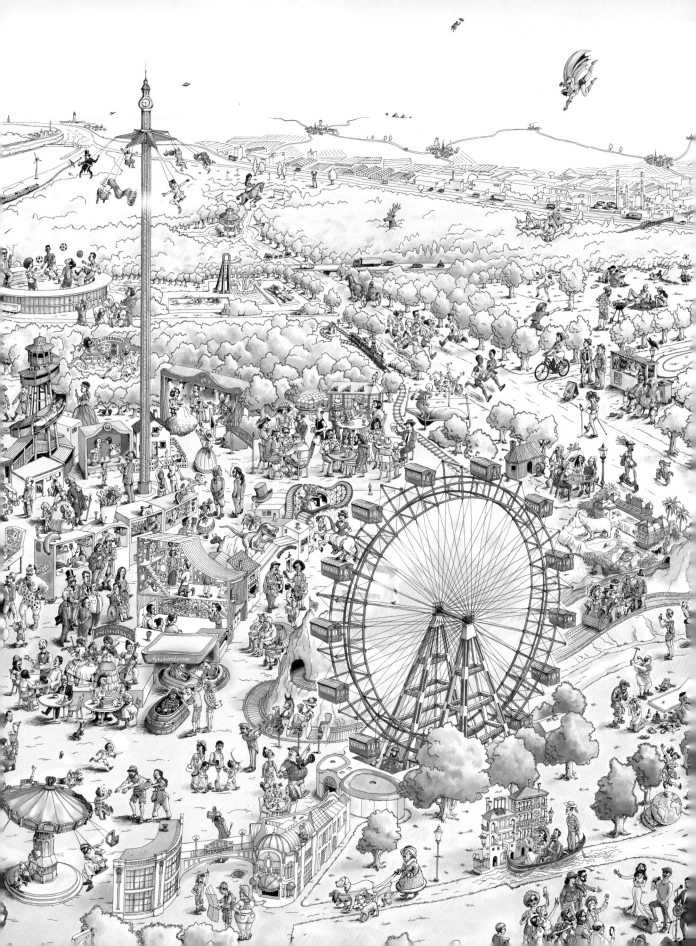

What Is the Prater?

"Few of the world's capitals have anything quite like our Prater. Is it a park? 'No.' Is it a meadow? 'No.' Is it a garden? 'No.' Woodlands? 'No.' Pleasure grounds? 'No.' What is it then? 'All of these combined.'"

This variety of forms and uses, as described by the writer Adalbert Stifter in 1844, still applies today to the 1,500 or so acres that lie between the Danube and the Danube Canal. The Vienna Prater is many things—a park for pleasure and recreation, a natural landscape, an open space, and a sports ground.

It was opened in 1766 by Emperor Joseph II, marking a revolutionary step for Vienna and the beginning of a new era. For centuries, the imperial hunting grounds had been closed to the public. But from this point on they were open to "everyman," in other words, to all—for strolling through meadows and along avenues, for eating and drinking, for dancing and amusements in the many taverns that soon sprang up, for music and theater on simple wooden stages and in elegant coffee houses. Emperor Joseph II took this step with a view to making profound changes in society. In the spirit of the Enlightenment, the Prater functioned as a social testing ground, one where the traditional hierarchy of class and religion was to be overcome. For the first time, "leisure" was recognized as a distinct period of time set aside for individual recreation and as separate from the prescriptions of religious feast days. Notions of utility also played an important role, with the belief that leisure would raise productivity and make the state more competitive among the major European powers. Under the emperor's plans, the Prater would stimulate encounters between the different social classes, and in particular introduce the aristocracy to bourgeois thought.

For more than two centuries, the Prater was Vienna's most important location for innovation and experimentation—a laboratory, even. It was here that the public first learned about almost all new technological, social, and cultural developments: from optical equipment to spectacular feats of engineering such as the construction of the Rotunda and the Riesenrad Ferris wheel, from hot-air balloon flights to the film *A Trip to the Moon*, from the inner workings of the human body in anatomical museums to modern sports such as football, cycling, and tennis, from high society's flower parade to the first workers' May Day march.

For most Viennese, the Prater was a window to the wider world. Panoramas, dioramas, room tours, and grotto trains featured images of foreign cities and countries. Zoos, menageries, and circuses brought wild and exotic animals to Vienna.

The Prater was a place where people grappled with the big questions of modern life in ways that were enjoyable, instructive, spectacular, humorous, and transformative. These were questions about ideal forms of human society, attitudes to nature, animals, technology, and science, about political power and how the world is organized, and about notions of beauty and the good life.

Prater Panorama 2024 by Olaf Osten (detail)
Covering an area of almost 1,000 ft², the Prater Panorama by artist Olaf Osten tells the nearly 260-year history of leisure and entertainment in the Prater.

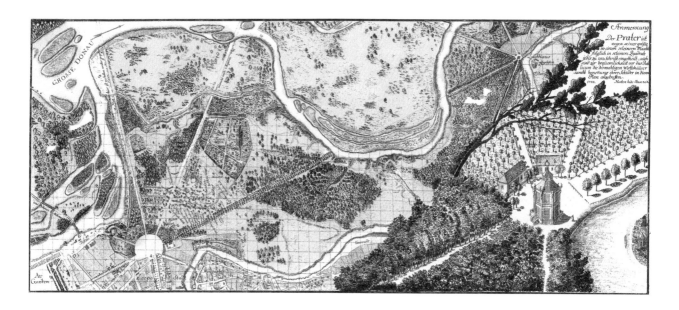

Joseph Daniel von Huber (attributed):
Plan of the Prater, 1782
Colored copper engraving, Wien Museum, inv. no. 169784

This is the first plan of the Prater following its opening in
1766. The Danube's then meandering riverbed is visible
in the north and east, while the south shows the arm that
later became the Danube Canal. The Praterstern (Prater
Star) is depicted in the lower left, its name derived from
the seven avenues meeting there. Symmetry and straight-
ness corresponded to the ideals of an enlightened city.
The Prater Hauptallee (Main Avenue) leads straight to
the Augarten park and Emperor Joseph II's palace. To the
Praterstern's north and west are a meadow for fireworks
and the 50 or so concessions at the Wurstelprater. On
the right is the Imperial Pleasure-House, which had been
created in the 16th century along with the Hauptallee.

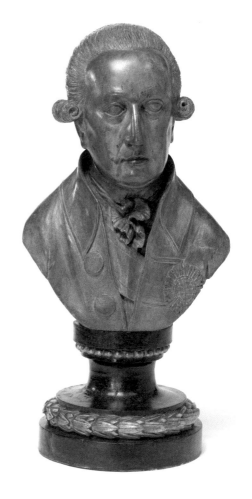

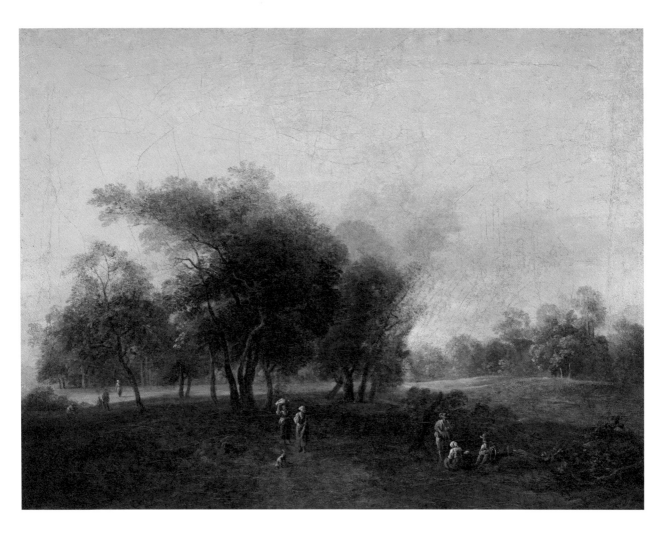

Jakob Matthias Schmutzer:
Outing in the Water Meadows
of the Prater, ca. 1790
Oil painting, Wien Museum,
inv. no. 94354

This painting is one of the earliest depictions of the Prater. Outdoor sketching—a practice rooted in the Enlightenment—had become popular at art academies, and interest in Vienna's Prater landscape began to grow. Jakob Matthias Schmutzer, who painted the Prater floodplains, introduced this new teaching method at the Copper Engraving Academy, founded in 1763.

Bust of Joseph II, 2nd half of the 18th century
Wood, Wien Museum, inv. no. 134092

A scion of the Habsburg dynasty, Emperor Joseph II (1741–1790) was an important representative of enlightened absolutism in Europe. He limited the power of the Catholic Church, tolerated the religious practice of Protestants and Jews, and pursued a progressive economic, legal, and social agenda, including the liberalization of trade laws, the abolition of the death penalty, and an end of serfdom. Enhancing human utility for the state was an overt goal and played a major role in Joseph's decision to open the Prater as a recreational area for all.

**Riesenrad Ferris wheel
under construction, 1897**
Photo: unknown
Wien Museum, inv. no. 175016

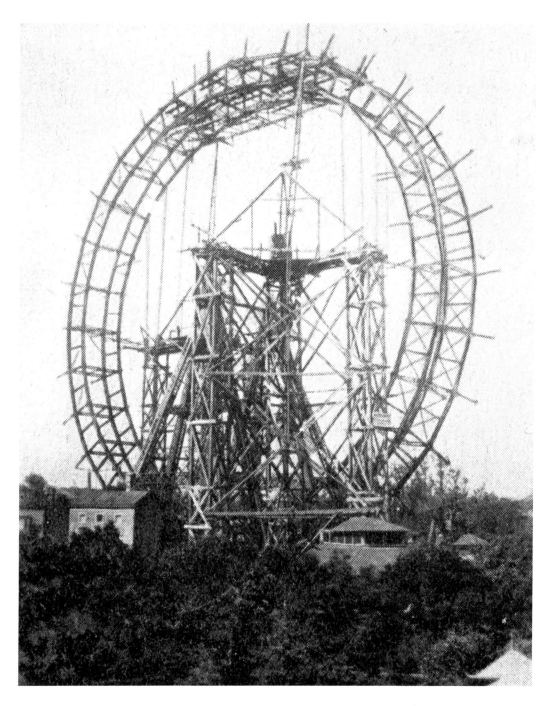

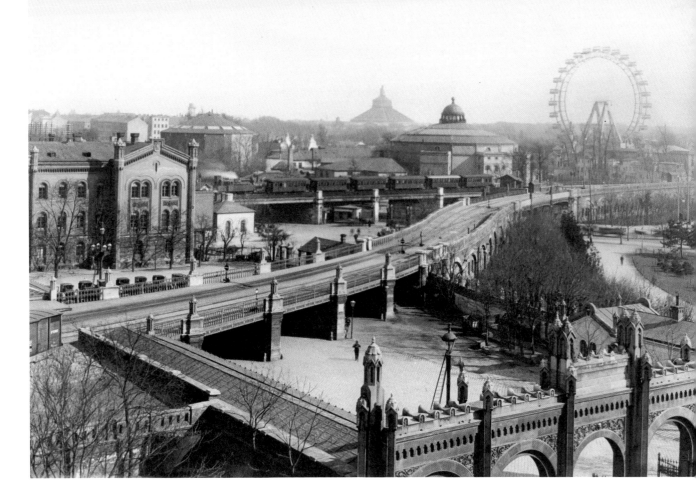

**View over the roof of the
Nordbahnhof railway station**
Photo: Bruno Reiffenstein (?)
Wien Museum, inv. no. 44360
Top center is the *Circus Busch* build-
ing, on the left the building of the
former *Circus Carré*, in the back-
ground is the Rotunda, to the right
the Riesenrad Ferris wheel, after 1897

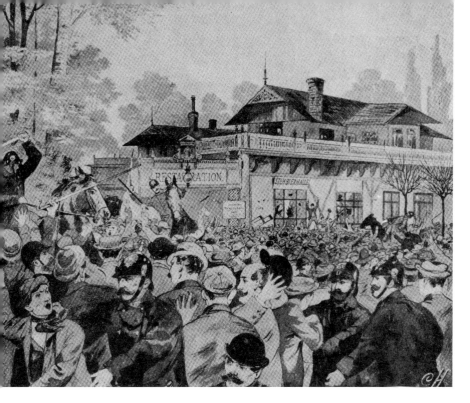

Police action in front of the Swoboda Inn on May 1, 1896, from Wiener Bilder, May 10, 1896
Wien Museum, inv. no. 172084

When Vienna's working class started to organize themselves politically, they used the Prater as a site for collective action. The first May Day march took place there in 1890, following difficult negotiations with the authorities. Upon gathering at various taverns in the Prater, the workers all started to sing a worker's song as a form of mass political demonstration. When workers were barred from entering the Swoboda Inn in 1896, riots broke out in front of the restaurant.

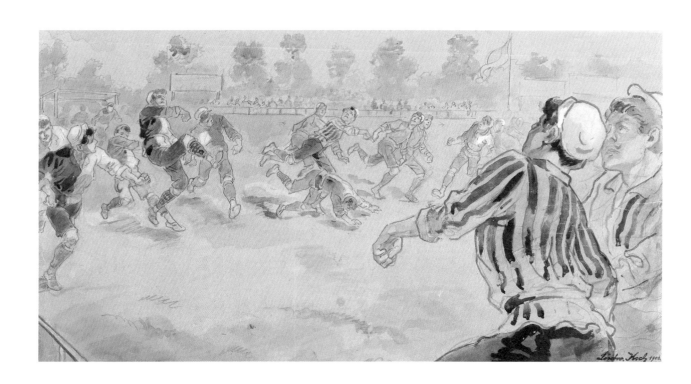

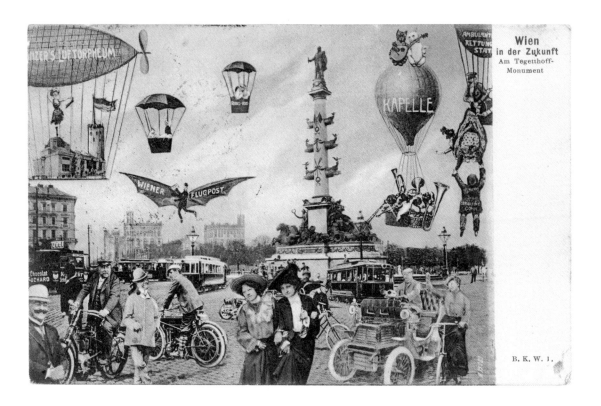

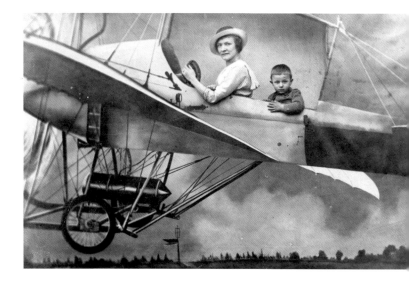

Ludwig Koch: Football Match of the "Cricketers" at the Prater, 1906

Gouache, Wien Museum, inv. no. 77607

Soccer was brought to Vienna by British expats. In August of 1894, the first two clubs were founded within days of each other: the "First Vienna Football Club" and the "Vienna Cricket and Football Club." Founded by the British landscapers working for Baron Nathaniel Anselm Mayer Rothschild, the former played at the Hohe Warte in today's 19th district. The latter played at the Prater, where the new sport quickly attracted interest. "Wild soccer"— playing without permission from the Prater authorities—was technically forbidden. But it was difficult to prevent.

Collotype postcard: "Vienna in the future," 1907

Verlag Brüder Kohn KG
Wien Museum, inv. no. 313247

Postcard from Emma Willardt's rapid photography studio: a woman and a boy in a dummy airplane, ca. 1910

Alexander Schatek (Pratertopothek), ID 0093653

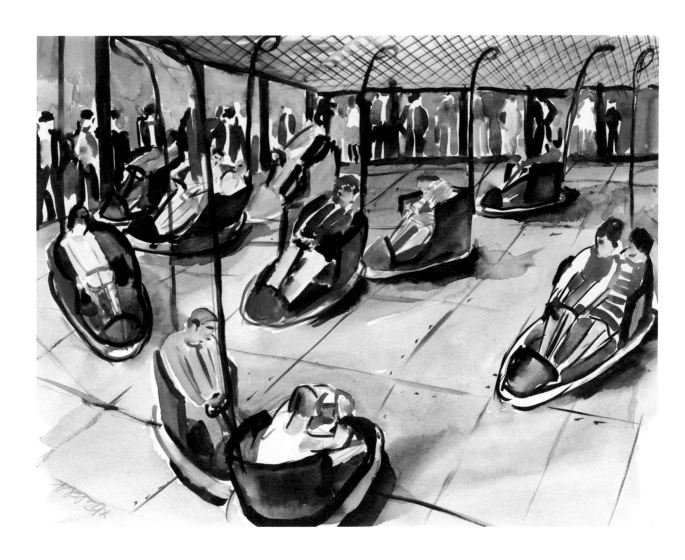

Otto Rudolf Schatz: "Bumper Cars," 1929
Watercolor, Wien Museum,
inv. no. 249752
The first bumper car concession
opened at the Prater in 1926, a time
when most people could not afford
their own car. The artist Otto Rudolf
Schatz (1900–1961) often depicted
scenes from everyday life, paying
particular attention to social issues.

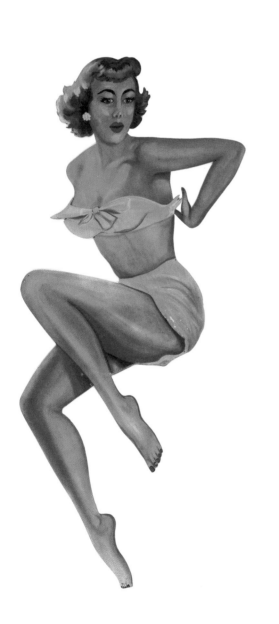

Hall of mirrors at the Prater, 1957
Photo: Leo Jahn-Dietrichstein
Wien Museum, inv. no. 228314

Pinup girl from a shooting gallery, 1958
Hardboard, Elisabeth Brantusa

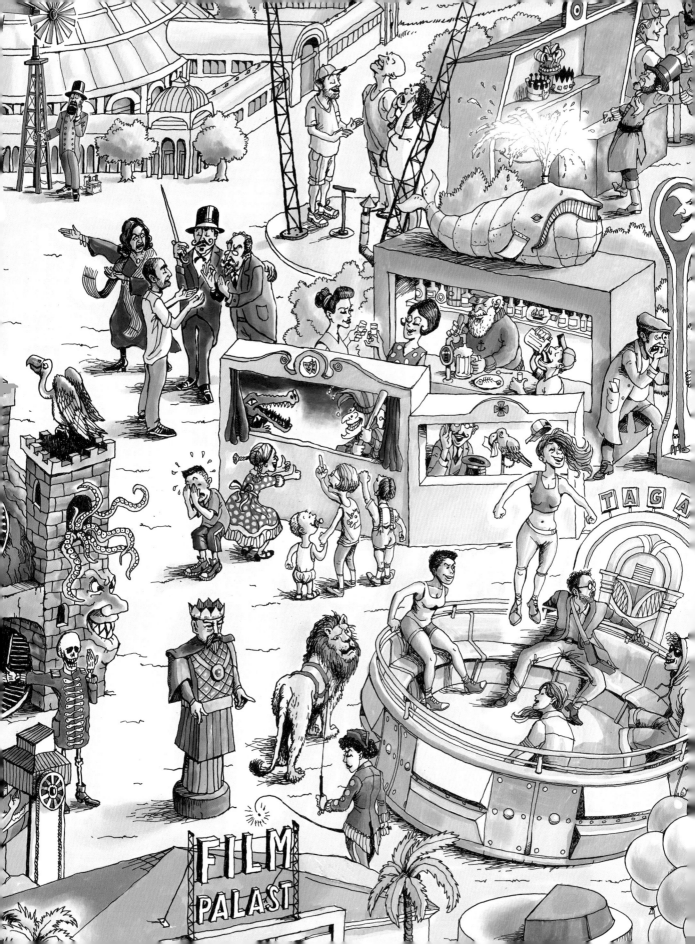

Why "Wurstelprater"?

Soon after the imperial hunting grounds were opened to the public, an amusement district emerged in the area of the Prater closest to the city. By the first half of the 19th century it had become known as the "Wurstelprater," and it is still there today. The name comes from the coarse and comical figure of Hanswurst—Mr. Punch in English. In Vienna, he became the star of the many puppet theaters ("Wursteltheater") in the Prater. Mr. Punch's companions and antagonists included the Crocodile, the Princess, the Magician, the Grandmother, the Police Constable, and the Burglar. He could be humorous and questioning, but also brutal. It was only in the 20th century that the character became a firm favorite with children.

With the huge growth of cities in the 18th century, royal hunting grounds and gardens across Europe—in London, Berlin, Paris, and Vienna—were opened to the general public for recreational purposes. Taverns, coffee houses, and refreshment kiosks followed, as well as amusements and attractions such as merry-go-rounds, swings, skittle alleys, circuses, menageries, and panoramas.

These modern amusement parks reached their heyday around 1900. The new industrialized world of work and modern urban life, with their harsh conditions and merciless discipline, prompted people to seek out places that provided a distraction from the daily routine and promised instant happiness. Mechanical attractions, often from the USA, such as Ferris wheels and roller coasters offered new types of bodily experience and manufactured sensations.

Following World War II, growing prosperity in Western countries—cars, televisions, travel—spelled a crisis for these amusement parks around the world.

But in the Vienna Prater, time moved at a different pace. Longer than elsewhere, the traditional amusements and shows, the simple taverns and beer gardens, and the venues offering quality artistic and musical entertainment held their own amidst the new technologies. Today, almost no other amusement park is as deeply rooted in a city's identity as the Wurstelprater in Vienna.

Prater Panorama 2024 by Olaf Osten (detail)
In 1883, engineer Josef Friedländer (top left) exhibited the world's first wind turbine at the *International Electrical Exhibition*. Architects Zaha Hadid (Vienna University of Economics and Business), Carl von Hasenauer (1873 World's Fair), Otto Wagner (liked to celebrate in the Prater), and Michael Wallraff (Prater Museum) are deep in conversation. At Barbara Fux's famous puppet theater, Mr. Punch is about to whack the naughty Crocodile. The whale on the roof of the tavern of the same name now lives in the Wien Museum at Karlsplatz. Looking scared on the *Tagada* fairground ride is actor and director Josef Hader, who shot the film *Wild Mouse* in the Prater in 2017. Animal tamer Miss Senide, who grew up in the Prater and came to fame in the 19th century, is taking her favorite lion for a walk.

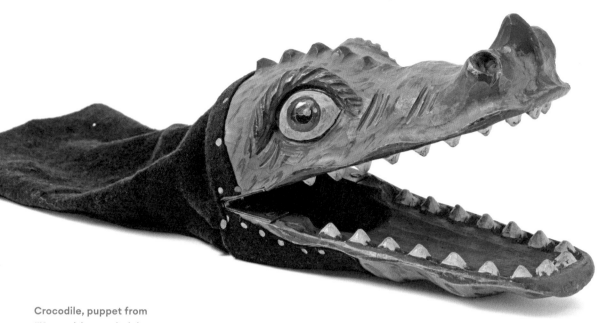

Crocodile, puppet from
"Kasperltheater bei der
Walfischgrottenbahn," ca. 1890
Wien Museum, inv. no. 125356/2

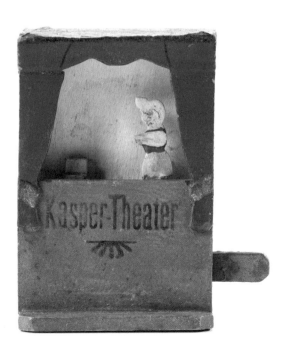

Punching dummy owned by
the painter Egon Schiele, 1890s
Wood, Wien Museum, inv. no. 142466

Punch and Judy show owned by
the painter Egon Schiele, 1890s
Wood, Wien Museum, inv. no. 142780

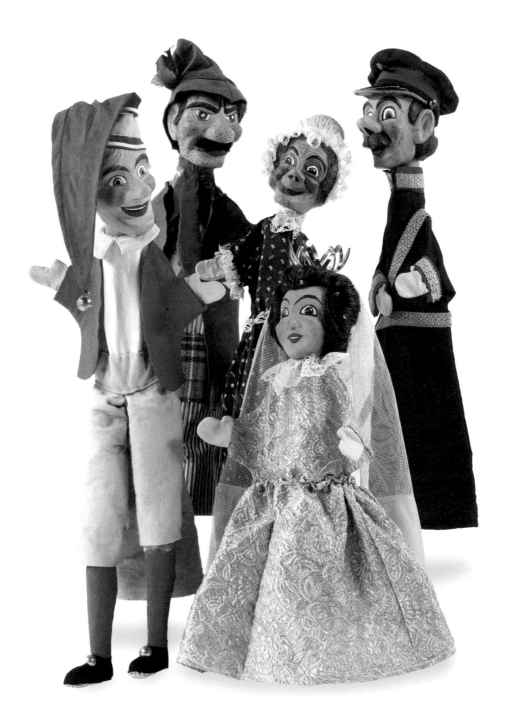

**Gerd and Lisl Hoss: Puppets
(Mr. Punch, Burglar, Grandmother,
Princess, and Police Constable) from the
Punch and Judy Theater "Der sprechende
Wiener Kasperl," ca. 1948**
Wien Museum, inv. no. 305696, 305704,
305699, 306701, 305706

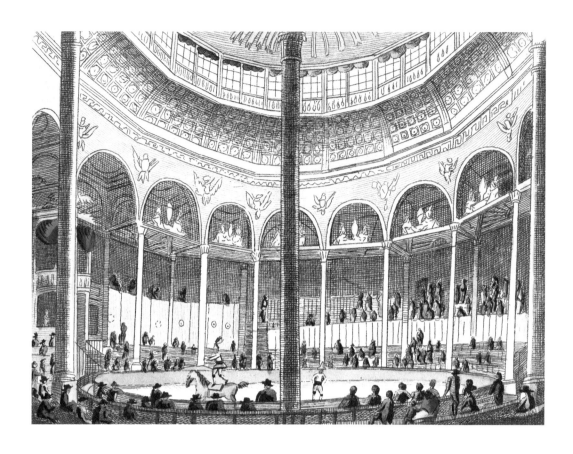

Circus de Bach or
Circus Gymnasticus, ca. 1812
Colored copper engraving,
Verlag Artaria & Co, Wien Museum,
inv. no. 105584

Circuses around 1800 mainly
featured displays of riding skills. In
1808, trick rider Christoph de Bach,
who was born in present-day Latvia,
commissioned the Circus gymnas-
ticus, a round, wooden building in
the Prater. It had space for 3,000
spectators and was designed by
renowned Viennese architect Joseph
Kornhäusel.

Trick rider in the Circus de Bach
or Circus Gymnasticus, ca. 1818
Woodcut, Wien Museum,
inv. no. 120697

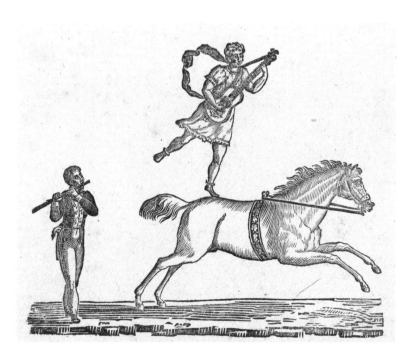

Jakob Alt: Panorama on the Hauptallee, 1815

Watercolor, Wien Museum, inv. no. 15167

Starting around 1800, panoramas began to be shown in specially built round structures made of wood. Invented in England, they afforded spectacularly realistic views of cities and landscapes along with depictions of historic events. The panorama building on the Hauptallee was created in 1801. Its proprietor, the Englishman William Barton, presented cityscapes of London, Vienna, Prague, Paris, and St. Petersburg. Panoramas were part of a new culture of seeing the world. Other modern technologies did the same, including dioramas, room tours, and later, movies.

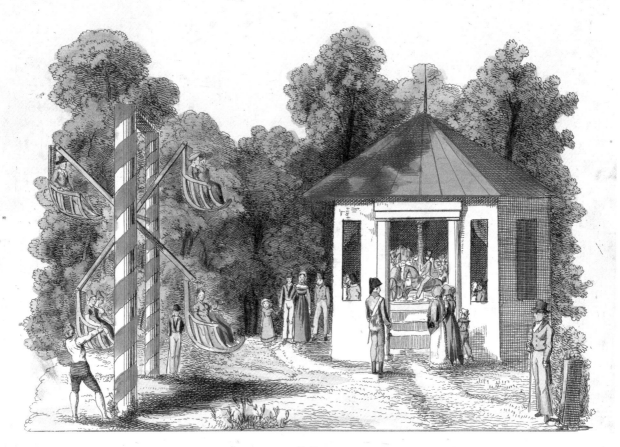

Wien bey J. Bermann.

**Merry-go-round and wheel
in the Prater, ca. 1800**
Colored copper engraving
Wien Museum, inv. no. 81546
Small Ferris wheels with hanging
seats were among the earliest
amusements in the Prater. Based
on their purported origin, they
were also known as "Russian
swings."

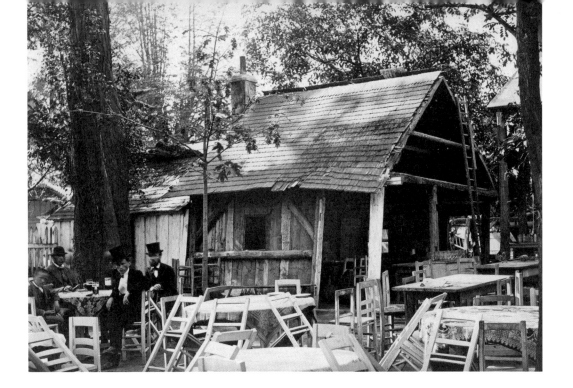

**The "White Ox tavern" and
"English Horseman inn," from the photo
series "The 'old' Vienna Prater," 1873**
Photo: Michael Frankenstein
(Vienna Photographers' Association)
Wien Museum, inv. no. 15205/8, 9

With the coming of the World's
Fair in 1873, the Wurstelprater was
"regulated." The old inns that were
often very makeshift had to make
way for new structures. The "Vienna
Photographers' Association," which
had been commissioned to document
the world's fair, captured the old
buildings before they were torn down.

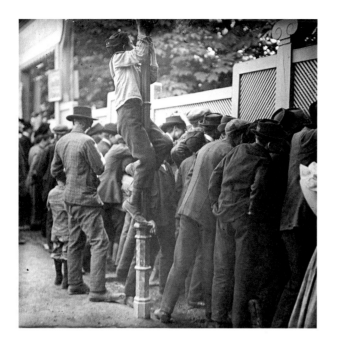

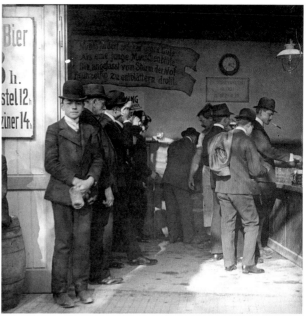

Onlookers, ca. 1906
Photo: Emil Mayer
Wien Museum, inv. no. 111448/81
Viennese lawyer Emil Mayer
(1871–1938) was one of Austria's
leading amateur photographers
around 1900 and an honorary
member of several photographers'
associations in Austria and abroad.
His work mostly features candid,
documentary street scenes and
shots of "Viennese types" taken
in Vienna's city center and in the
Prater. His slide lectures on the
Wurstelprater became legendary.

Beer booth in the Prater, ca. 1906
Photo: Emil Mayer
Wien Museum, inv. no. 111448/72

Prater-goers, ca. 1906
Photo: Emil Mayer
Wien Museum, inv. no. 111448/1

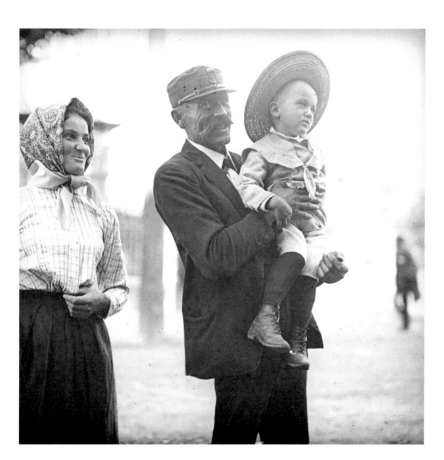

Swing ride, 1957
Photo: Leo Jahn-Dietrichstein
Wien Museum, inv. no. 228308

Swing ride in the Prater, 1957
Photo: Leo Jahn-Dietrichstein
Wien Museum, inv. no. 228283

**Shooting gallery in the
Wurstelprater, 1957**
Photo: Franz Hubmann
Wien Museum, inv. no.
MUSA 224/2000/0

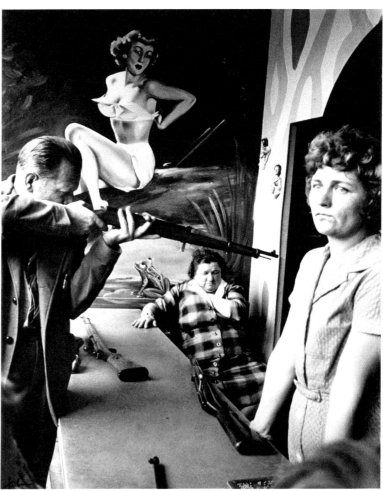

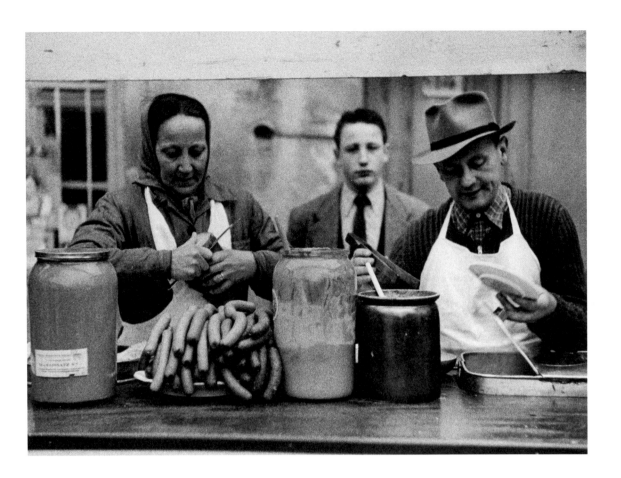

Sausage stand in the Prater, ca. 1960
Photo: Leo Jahn-Dietrichstein
Wien Museum, inv. no. 228306

**Advertising figure for a
hotdog stand in the Prater, 2020**
Photo: Tom Koch

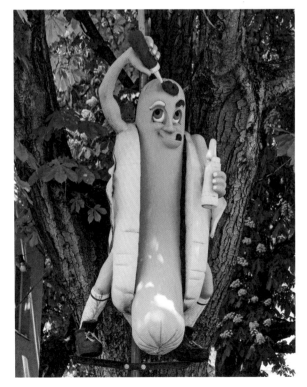

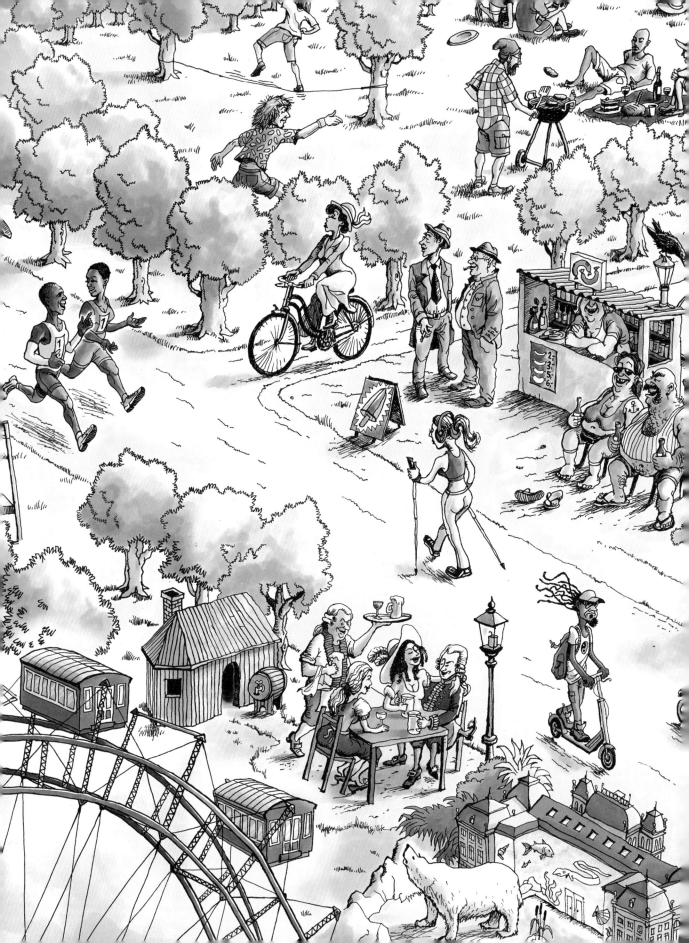

A Place for Everyone

Historically, the Vienna Prater had a clear social structure. The Wurstelprater was a place for everyone—with its simple taverns, amusements, and attractions, it fulfilled an important social function, especially in multiethnic Vienna. Alongside this, the Prater Hauptallee (Main Avenue), stretching over 2.5 miles with coffee houses and restaurants, was a place for high society. Court, aristocracy, and bourgeoisie took part in exclusive carriage rides ("Pratercorso") or gathered at the racecourses in Krieau and Freudenau.

In the literary imagination, in texts by Adalbert Stifter, Arthur Schnitzler, Felix Salten, and Stefan Zweig, the mixing of social classes became a reality, with tales of socially unequal lovers, fleeting sexual adventures, or the desire to be part of something. This also made the Prater a hotspot for experiencing the crises of modern life, with the search for happiness often ending in failure.

The sheer size of the Prater, with remote areas of largely untouched nature combined with its distance from the city, fueled the idea of the Prater as a space that was seemingly free from state and social control—a place for autonomous gatherings, novel and unfamiliar activities, and clandestine love affairs; and a refuge for outcasts, people in need of protection, and crooks. Clear empirical proof of these ideas is, however, harder to find. On the contrary: The Prater, which was owned by the imperial family until 1918, was under heavy surveillance and many activities were limited or even banned—at first, even playing soccer on the Prater's meadows was prohibited.

As the city grew rapidly, the Prater became Vienna's most important location for mass events—spectacles such as fireworks and hot-air balloon flights, imperial festivals and victory parades, the World's Fair in 1873, large exhibitions and trade fairs, political sporting events in the Prater Stadium built in 1931 (now the Ernst Happel Stadium), international soccer matches, and music events.

To this day, the Wurstelprater continues to resist any form of centralized management which, in other cities, has turned entertainment and leisure zones into amusement parks run on a purely commercial basis. The Prater remains open to all, and there are no admission fees.

Prater Panorama 2024 by Olaf Osten (detail)
Running along the Prater Hauptallee is Kenyan athlete Eliud Kipchoge, who ran the marathon distance in under two hours in 2019, setting a new world record. Wolfgang Amadeus Mozart and his wife Constanze are celebrating with friends at one of the famous coffee houses on the Hauptallee. In 1788, he composed the light-hearted canon *Let's go to the Prater, let's go to the Hetz*, still a popular soundtrack for an outing to the Prater. People are relaxing, playing sports, having a barbeque or a picnic, or simply people-watching.

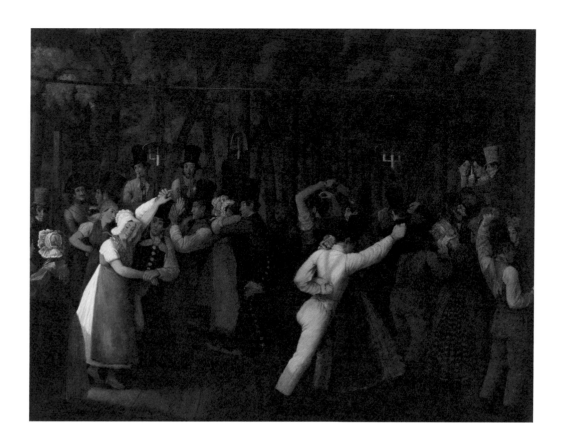

Michael Neder: "Five-Penny-Dance in the Prater," 1829
Oil painting, Wien Museum, inv. no. 48755

There was no admission charge to the dance halls at the Prater's simple inns. But patrons had to pay five kreutzer (analogous to pennies) for each individual dance. The term "five-penny-dance" thus became synonymous with the amusements enjoyed by the Prater's less well-off visitors.

Josef Hoffmann: Celebration on a Prater Meadow, 1863
Oil painting, Wien Museum, inv. no. 73246

**(Eduard?) Schäfer: Flower Parade
on the Prater Hauptallee, 1895**
Oil painting, Wien Museum,
inv. no. 71520

The first flower parade was held on
the Prater Hauptallee in the spring
of 1886. Initiated by the enterpris-
ing Princess Pauline Metternich
(1836–1921), it mobilized the who's
who of Viennese society, who showed
up in richly decorated carriages. The
tradition has continued, off and on,
until the present day.

**Hans Larwin: "A Couple,"
presumably in the Prater, ca. 1925**
Oil painting, Wien Museum,
inv. no. 49574

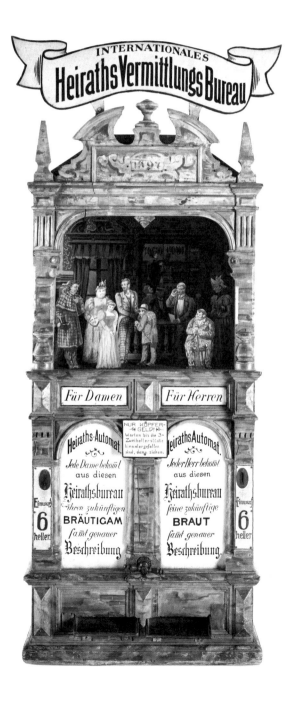

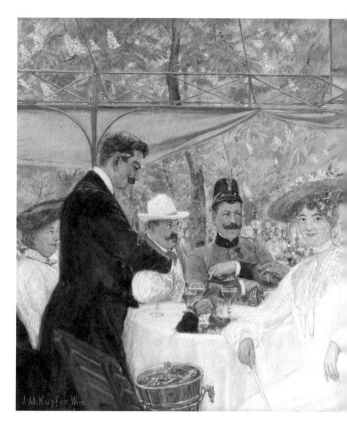

Johann Michael Kupfer:
In the Elegant Prater, 1904
Oil painting, Wien Museum,
inv. no. 74801
The "elegant Prater" referred to
the restaurants and coffee houses
on the Hauptallee.

**"International Office of Marriage
Brokerage," vending machine, 1897**
Wien Museum, inv. no. 173315
Standing in front of an attraction, the
vending machine made reference to
the era's booming market in marriage
brokerage. After inserting a coin, the
player received a small piece of paper
listing the characteristics of their
ideal match.

Trotting racecourse in the Krieau, derby in 1927
Photo: Martin Gerlach Jr.
Wien Museum, inv. no. 211864

There were two kinds of horse races, based on the different gaits employed. Aside from the full gallop, there was the slower trot. The first trotting races were held on the Hauptallee and featured Fiakers, Vienna's traditional horse-drawn carriages. In 1874, the Trotting Club was founded, and four years later a racecourse was built in the Krieau. While never considered as elite as the gallop racing practiced at the nearby Freudenau, trotting races remained popular well past the end of the monarchy.

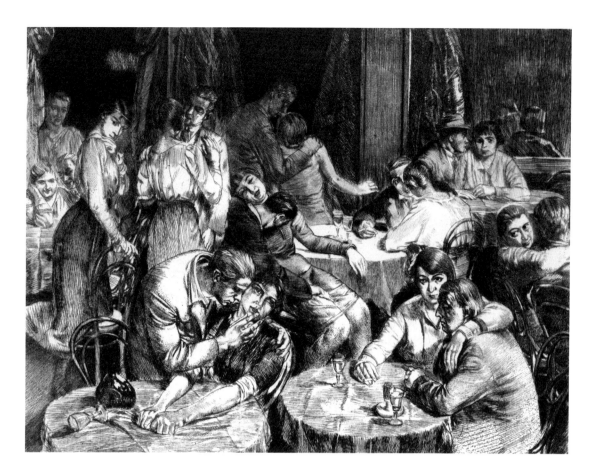

Christian Ludwig Martin:
"Prater Inn," 1931
Etching, Wien Museum,
inv. no. 52783

Karl Wiener: Organ Grinder
("Im Prater blüh'n wieder
die Bäume"), ca. 1929
Woodcut, Wien Museum,
inv. no. 250533/2678

Vienna's reputation as a cheerful city of music contrasted sharply with the reality of widespread poverty. This tension is the topic of this piece by artist Karl Wiener (1901–1949). *Im Prater blüh'n wieder die Bäume* ("The trees are in bloom again in the Prater") is one of Vienna's best-loved songs, a hymn to the city's enduring beauty written in the middle of World War I by Robert Stolz and Kurt Robitschek.

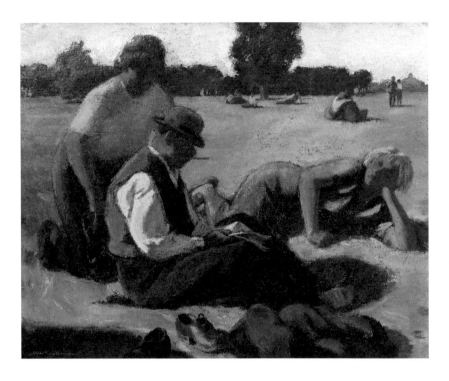

**Alfred Gerstenbrand:
Prater Meadow, 1933**
Oil painting, Wien Museum,
inv. no. 58770

**Alice Wanke: Playground
in the Prater, ca. 1935**
Oil painting, Wien Museum,
inv. no. 94440

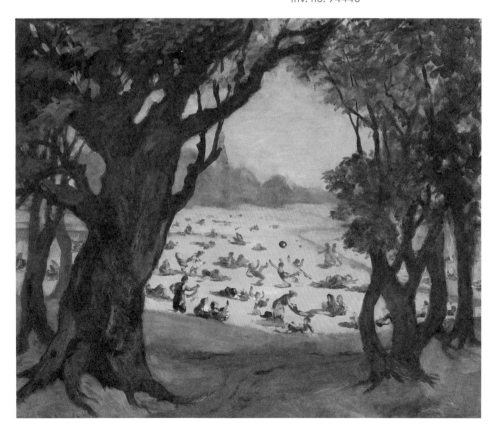

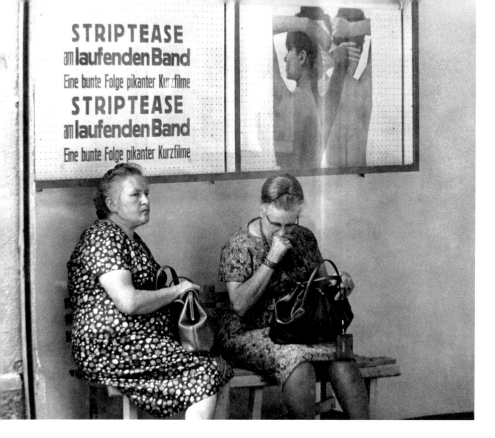

**Two women in front of a strip club
at the Prater, ca. 1970**
Photo: Votova, brandstaetter
images, inv. no. 664612

**Grandfather and grandchild
at the Prater, ca. 1970**
Photo: Barbara Pflaum, brandstaetter
images, inv. no. 519661

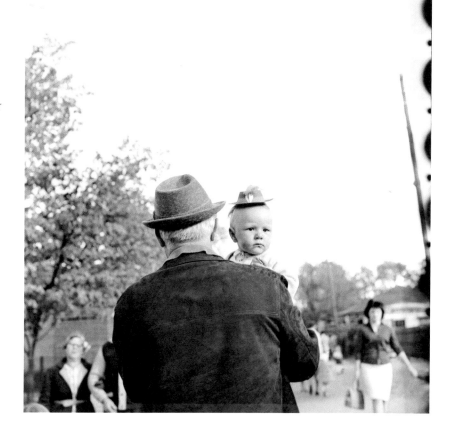

Young people at the Prater,
May 17, 1956
Photo: Votava, brandstaetter
images, inv. no. 00665405

Members of the Yugoslav community
on a soccer field, 1972
Photo: unknown, Wien Museum,
inv. no. 305785/5

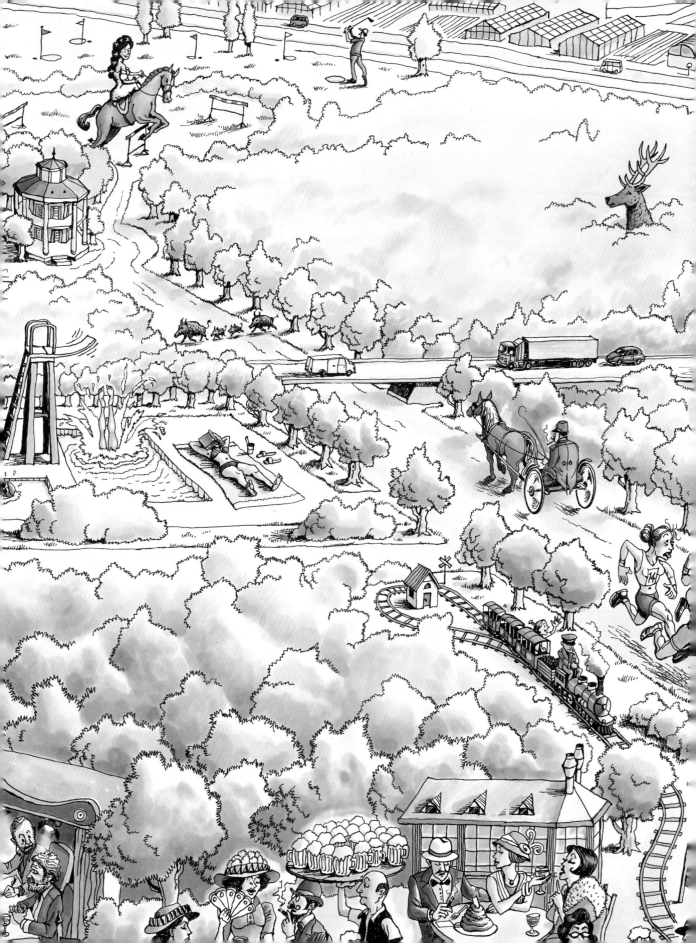

The Green Prater

The relationship between nature and the city is a key theme running through the Prater's history. Since it opened in 1766, the Prater has been a transitional zone, stretching from the built-up city via the loosely arranged Wurstelprater and the Hauptallee to the largely untouched woods and water meadows.

The name Prater, first documented in the 12th century, comes from the Latin term for meadow. In the Middle Ages, the Prater referred to a network of islands between several arms of the Danube.

It took on a more defined form in maps from the 17th century onwards, where it was bordered to the northeast by what would become the main arm of the Danube and to the south by the later Danube Canal. By this period, it was already a hunting ground used exclusively by the imperial family, and its shape was constantly changing due to the shifting course of the river: only technological interventions prevented the Danube from swallowing it completely. The Hauptallee was laid out in 1537/38. Initially called the "Long Corridor," the dead straight avenue ran from the entrance of the Prater to the imperial Pleasure-House, built in 1560.

Prater Panorama 2024 by Olaf Osten (detail)
Sisi (Empress Elisabeth) likes to go for a ride in the Prater. The golf course in Freudenau was opened in 1902 and is the oldest in Austria. At the end of the 2.5-mile-long Hauptallee stands the Lusthaus, built by Isidore Canevale in 1783. Not only wild boar and deer traverse the Prater, but a lot of cars on the freeway. The outdoor pool opened in Red Vienna in 1931, and trains have been running on the miniature railway since 1928. Serving staff at the legendary *Schweizerhaus* are famous for the number of tankards of beer and plates of roast pork knuckle they can carry.

The Danube was regulated between 1870 and 1875, straightening the main arm of the river and giving the Prater its present-day shape. Smaller channels were filled in and only a few streams, such as the Heustadelwasser, were preserved. This drastic intervention into the Danube river system was designed to protect the city from flooding, secure shipping routes, and create building land.

The development of the railway and public transport networks brought the Prater ever closer to the city, making it viable as a zone for urban expansion.

The first time this was done on a large scale was for the Vienna World's Fair in 1873, which was constructed on a 575-acre site. New districts emerged along the Danube and later the Danube Canal (Pratercottage). Sports clubs (for horse racing, tennis, athletics, football, and golf) also snapped up parts of the Prater for their activities and were at first socially exclusive organizations. Allotments were created during World War I and the following period, with the Prater Stadium (today the Ernst Happel Stadium) following in 1931. The whole area is crossed by railways and road left.

Since 1990, the Prater has been designated as a conservation area, meaning that the landscape is protected while also underlining its recreational significance for Vienna's population. But this does not categorically rule out further development and construction.

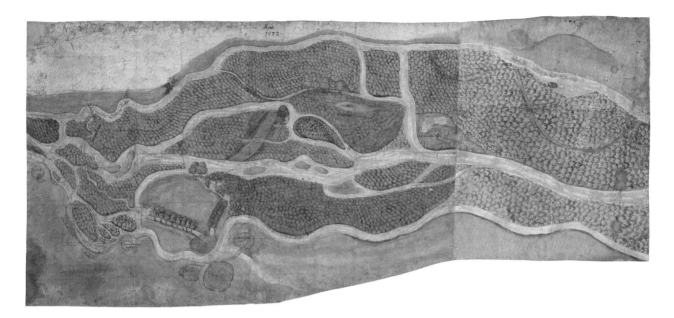

**First known plan of the Prater,
showing the arms of the Danube and
the outline of the city of Vienna, 1632**
Gouache, Wien Museum,
inv. no. 95961/4

Created in the course of a legal dispute, this early representation marks the Prater's entrance with a gate. Also visible are two main arteries, today's Taborstrasse and Praterstrasse.

**Emil Jakob Schindler:
Water Meadows in the Prater, ca. 1874**
Oil painting, Wien Museum,
inv. no. 117386

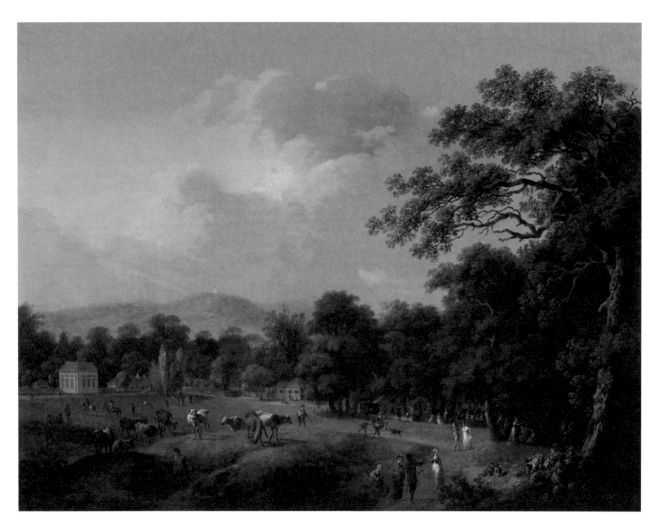

Laurenz Janscha:

At the Gallitzin Pleasure-House in the Prater, 1800

Oil painting, Wien Museum, inv. no. 70036

The painting emphasizes the proximity of different social classes in the Prater. Contrasting the shepherds with their grazing cattle are urbanites wandering the Haupt-allee or frequenting its inns. On the left is the Gallitzin Pleasure-House, built at the Prater's entrance by Russian ambassador Demetrius Mikhailovich Gallitzin in 1775. In 1794, it became the property of the imperial family, its surrounding park becoming known as the Kaiserwiese (Emperor's Meadow). After sustaining severe damage in 1945, the building was demolished.

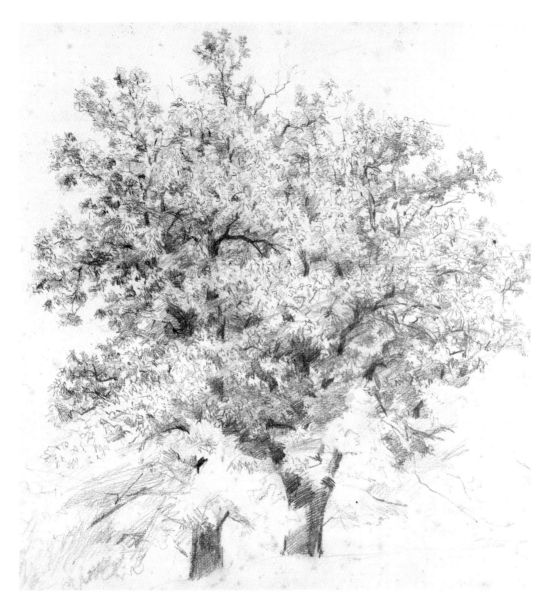

**Tina Blau: Study of a Tree
in the Prater, 1865–1872**
Pencil drawing, Wien Museum,
inv. no. 101402/2

Tina Blau (1845–1916) was one of
Austria's leading landscape painters.
Her studio was located in the Prater,
and she drew immense inspiration
from its scenery. She painted from
nature and could be seen with a wick-
er cart holding her easel and painting
utensils until well into old age.

**Tina Blau: "Autumn day. Prater
(In Krieau)," 1882**
Oil on canvas, Wien Museum,
inv. no. 31522

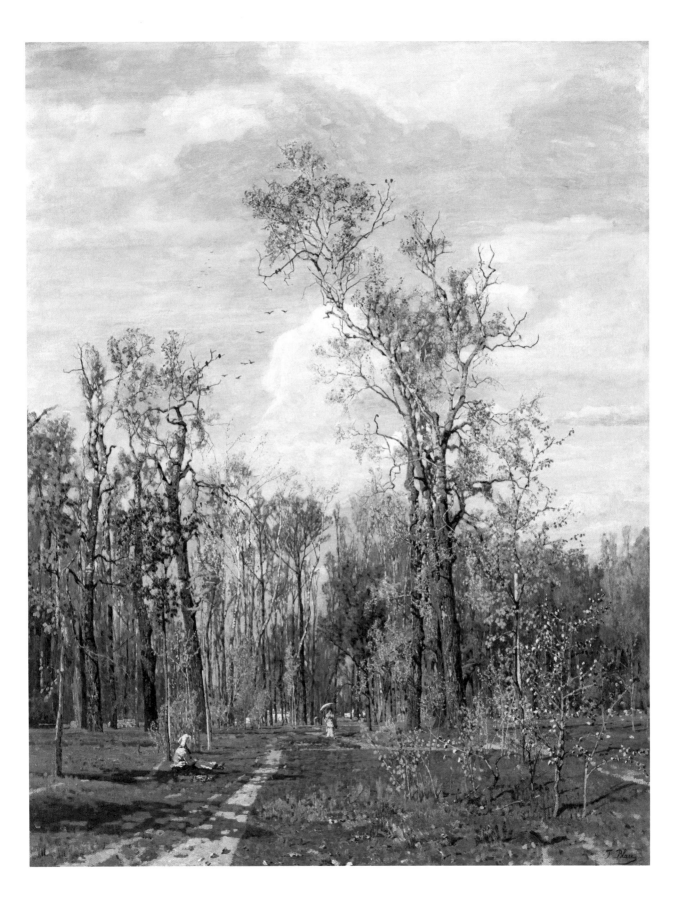

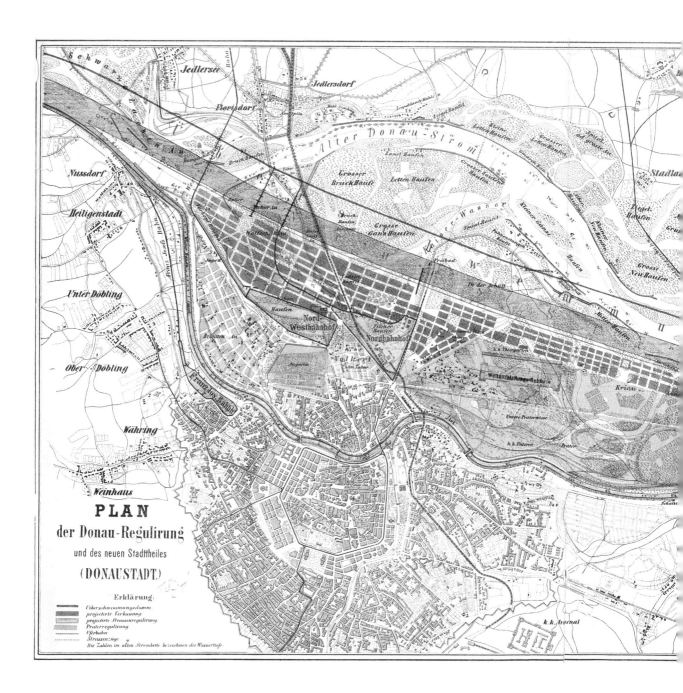

PLAN
der Donau-Regulirung
und des neuen Stadttheiles
(DONAUSTADT.)

Erklärung.

Ueberschwemmungsdamm
projectirte Verbauung
projectirte Strassenregulirung.
Praterregulirung
Pferbahn
Strassenzüge
Die Zahlen im alten Strombette bezeichnen die Wassertiefe.

48

Plan of the Danube Regulation with the New District of Donaustadt, 1871

Imperial-Royal Court and State Printing Office Vienna, Wien Museum, inv. no. 68558

In the 19th century, the Danube was reengineered to prevent flooding, gain land for urban development, and expand the shipping trade. For the Prater, the gigantic project—undertaken between 1870 and 1875—had far-reaching consequences. The changes in the riverbed reduced its size considerably and affected the area's water balance.

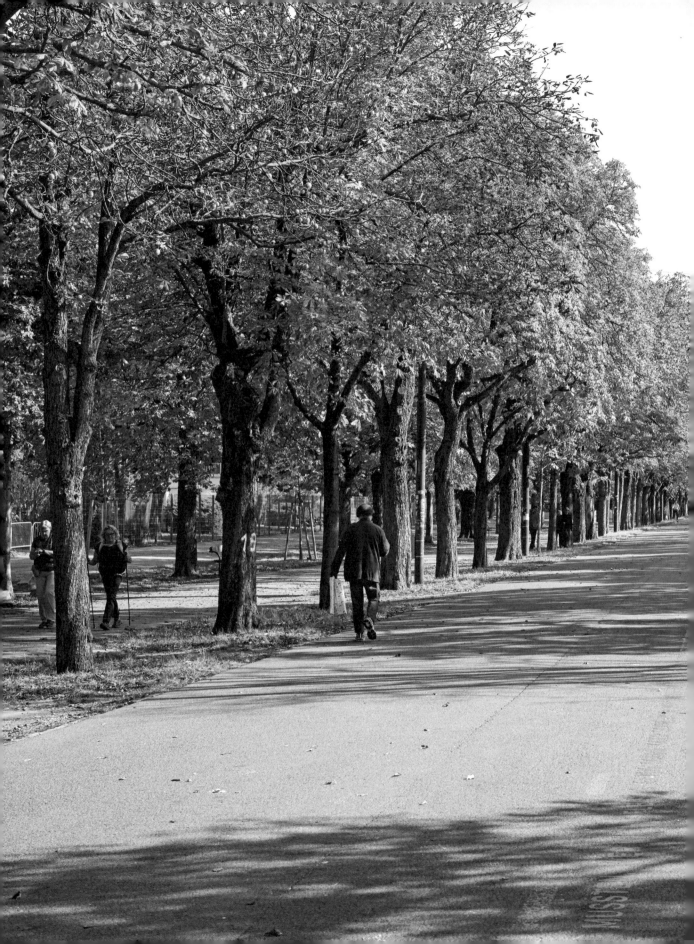

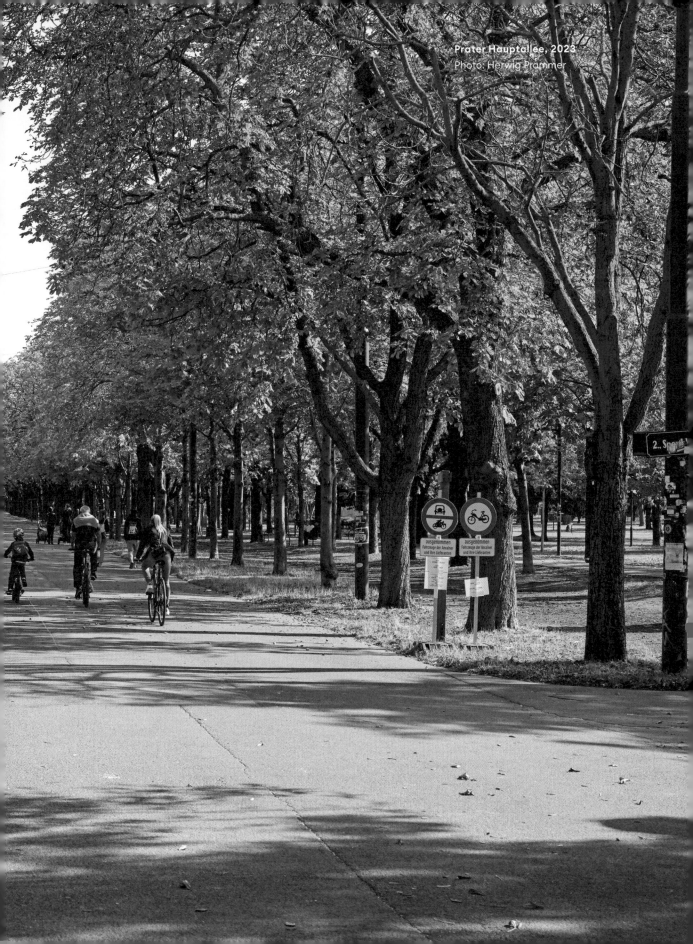

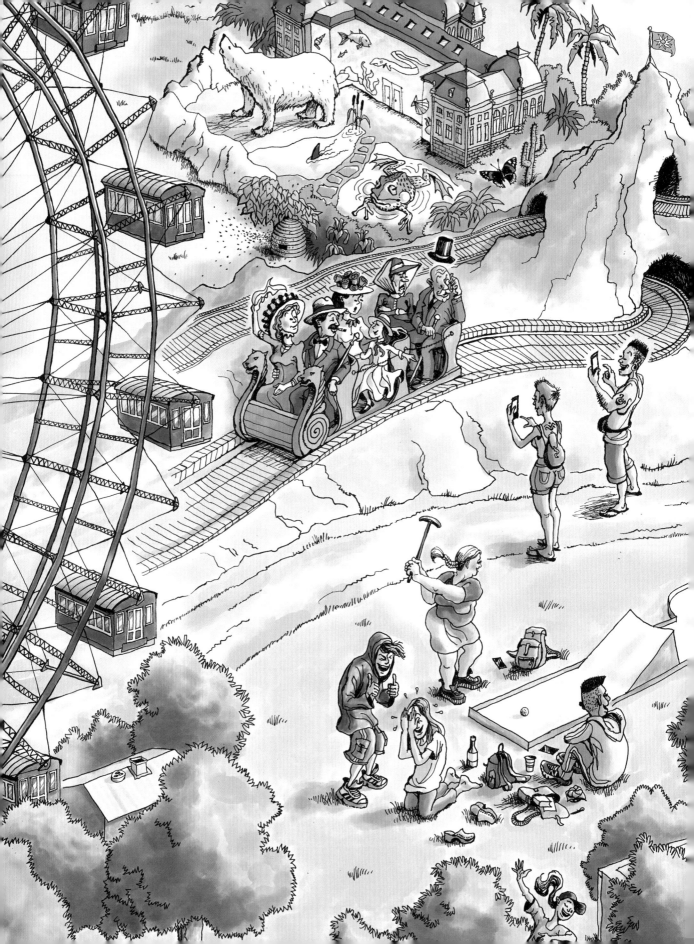

Animals

In the Prater, we can see how human interaction with animals has changed over time. In a whole variety of ways, animals have always mattered to humans here—as game animals and hunting trophies, as exotic showpieces in menageries and zoos, doing tricks in circuses or monkey and dog theaters, as "artists" in the flea circus, for horse racing and carriage rides, and as the fantastical beasts and monsters adorning the grotto trains, ghost trains, and houses of horror. Animals have also long been used in tavern names and signs—from deer, ducks, and geese to crows, swans, and even a whale.

Hunts were organized in the Prater for the entertainment of courtly society. Foxes, badgers, martens, hares, and wild cats were killed in cruel ways for the amusement of the noble guests.

Menageries and traveling zoos arrived in the Prater in the late 18th century. They brought unknown animals from Europe's colonial empires to a wider public, often accompanied by fantastical stories.

A more serious scientific approach was taken by the zoo "Wiener Thiergarten am Schüttel" (1863) and the Marine Aquarium (1873) at the beginning of the Hauptallee, which later found global renown as the Institute for Experimental Biology. Tricks, whether performed in circuses or monkey and dog theaters, demonstrated the power of humans over animals—often through the use of cruel methods.

Today, protecting animals and conserving the natural environment take priority in the Prater. Deadwood is food for numerous insects, stag beetles for example, and is essential for woodland biodiversity. Waterways such as the Heustadelwasser and Mauthnerwasser are important stopover points for migrating birds and provide habitats for native species. It is possible to see swans, grey herons, gulls, mandarin ducks, mallards, and a great number of carrion crows and hooded crows.

Prater Panorama 2024 by Olaf Osten (detail)
A large freshwater and marine aquarium opened on the Prater Hauptallee (see following pages) in 1873 to coincide with the Vienna World's Fair. The Prater's first roller coaster was built in 1909 in the *Venice in Vienna* theme park on the Kaiserwiese. Its original name was the *American Scenic Railway* and the 1-mile-long ride through mountain scenery took 8 minutes. It was constructed by American roller coaster pioneer LaMarcus Adna Thompson and destroyed by a fire in 1944. Sitting in the front car are Felix Salten and his wife Ottilie. His 1911 book *Wurstelprater* was a homage to the amusement park. As a Jew, Salten was forced to flee Austria in 1939. Gabor Steiner was also forced to emigrate. Steiner was the founder of *Venice in Vienna* and built the Riesenrad Ferris wheel in 1897 as the very latest in fairground attractions.

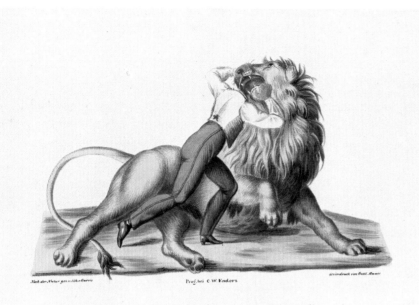

Nach der Natur gez. u. lith. v. Gareis. Prag, bei C. W. Enders. Steindruck von Gottl. Haase.

Herr van Aken steckt seinen Kopf in den Rachen des Löwen.

II.

Anton Gareis: "Mr. van Aken puts his head down a lion's throat," 1833
Colored lithograph, Wien Museum, inv. no. 109922/2

Hermann van Aken (1797–1834) was a member of the Dutch van Aken family, early 19th-century animal traders who toured Europe with their menageries. In 1819, Hermann van Aken struck out on his own with a show featuring predators. In Vienna, he was an advisor to the imperial zoo at Schönbrunn and married Baroness Katharina Sidonia Dubsky, daughter of a waxworks owner.

The wrestler Georg Jagendorfer with a bear, ca. 1895
Photo: A. Huber, Wien Museum, inv. no. 175669

The photo shows the famous wrestler and weightlifter Georg Jagendorfer with a bear. Are they fighting or embracing?

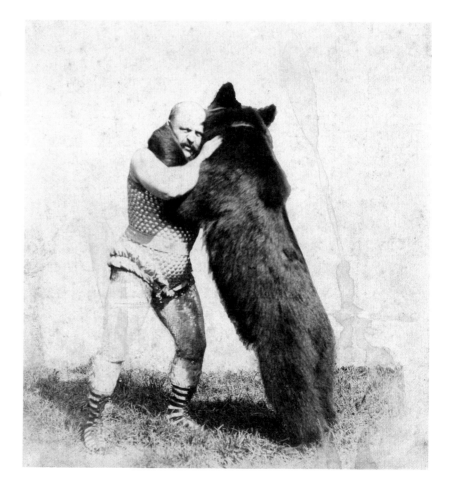

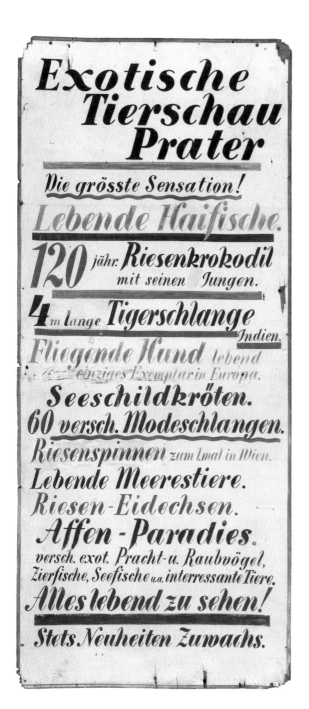

Advertisement for an "Exotic
Animal Show" at the Prater, 1930s
Wien Museum, inv. no. 173335

**Poster for Johanna Schreier's
"Affentheater im Prater"
monkey theater, 1850**
Wien Museum, inv. no. 66004/3
Monkeys were a popular Prater
attraction in the late 19th century.
They were dressed up and trained
to perform tricks, ride horses, enact
historical scenes, and make fun of
human frailties.

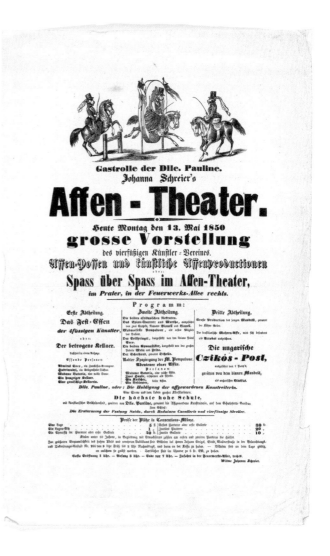

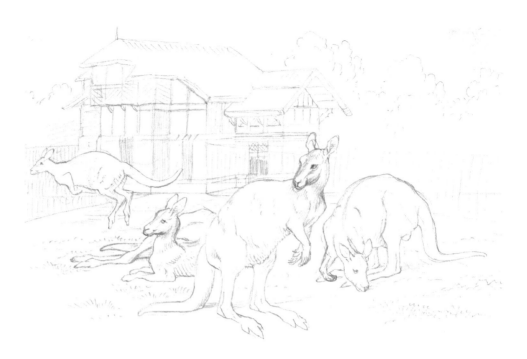

Franz Theodor Zimmermann:
Study of a Kangaroo at the
"Wiener Tiergarten," 1863
Pencil drawing, Wien Museum,
inv no. 95698/2

The "Wiener Thiergarten am Schüttel" (on today's Schüttelstrasse) was opened in 1863 as a middle-class counterpart to the royal zoo at Schönbrunn. Created by German zoologist Gustav Jäger (1832–1917), it was dedicated to research as well as education. When Jäger publicly supported Darwin's theory of evolution, he ran afoul of the Catholic establishment and left Vienna in 1866.

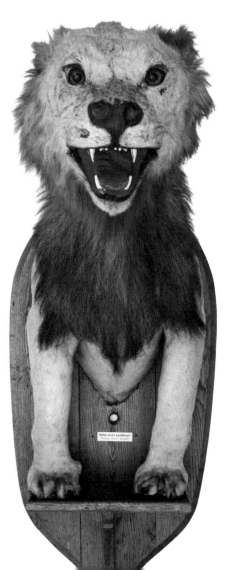

Stuffed lion of Miss Senide, ca. 1890
Wien Museum, inv. no. 173332

Miss Senide (1866–1923) was a famous lion tamer, who toured Europe and Asia with various circuses. In 1907, she returned to the Prater, taking over the concession of her mother Emma Willardt. Frequently injured during her daredevil performances, Miss Senide died peacefully in her sleep.

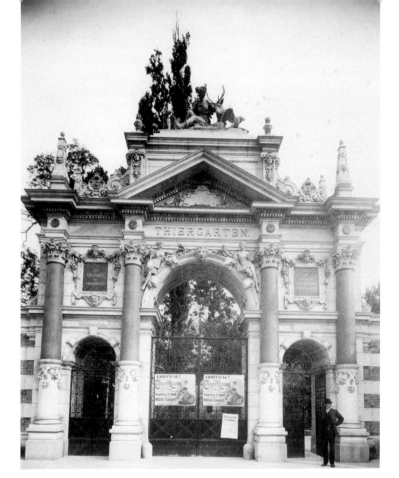

Entrance to the zoo on Laufbergergasse in the Prater, ca. 1894

Photo: August Stauda, Wien Museum, inv. no. 51951/50

After going bankrupt several times, the "Wiener Thiergarten am Schüttel" reopened in 1894 with new architecture and a novel concept that combined the actual zoo with many amusements and entertainments. There were restaurants, children's playgrounds, a romantic castle ruin, and a large arena. The latter was mainly used for colonial exhibits that presented groups of humans as a racist spectacle. Soon, these "Menschenschauen" ("human exhibits") were the zoo's most successful attractions. The zoo closed permanently in 1901.

"The Arctic Ocean and its Animal World" at the Vivarium on Prater Hauptallee, 1898

Photo: unknown, Wien Museum, inv. no. 159211

Carl Hagenbeck (1844–1913) was renowned for showing animals not in cages, but in their "natural" environments. His approach was an important precursor of modern zoos, including the inconspicuousness of the barriers between animals and visitors. Hamburg Zoo is still owned by his family.

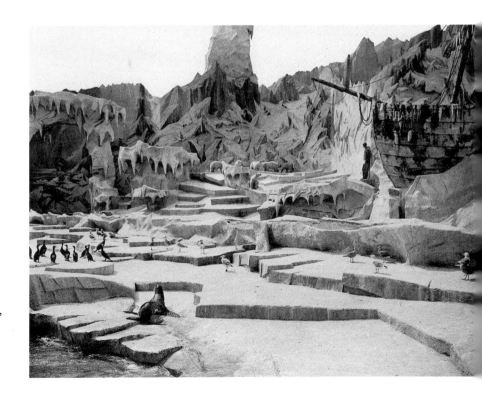

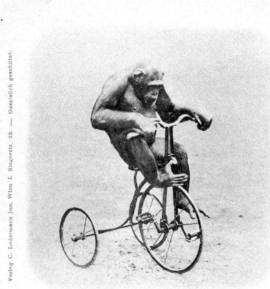

Verlag C. Ledermann jun. Wien I. Singerstr. 23. — Gesetzlich geschützt.

Gruß
aus dem Wiener Thiergarten,
k. k. Prater.

Chimpansin Maya.

**Postcard: The chimpanzee
"Maya" on a tricycle at the
"Wiener Thiergarten," 1890s**
Wien Museum, inv. no. 17788/337

**"The Flea Newspaper. A Biting Extra
Edition for the Visitors of the
Flea Circus at the Prater," ca. 1920**
Wien Museum, inv. no. 173099
Flea circuses are documented for the
Vienna Prater until the late 1940s.
Part of their attraction was the rich
cultural history of the relationship
between humans and fleas: pesky
vermin, on the one hand, and triggers
of erotic fantasies, on the other.

Die
FLOH - ZEITUNG
Eine bissige Extra-Ausgabe für
die Besucher des Flohzirkus im
Prater.

Der Flohzirkus übt stets seine unge-
schwächte Zugkraft aus und ist der
Sammelpunkt der Intelligenz Wiens,
zumal die Direktion sich redlich die
Mühe gibt, durch Neuausstattungen und
Programm-Neuerungen das Interesse
des p. t. Publikums stets rege zu halten.

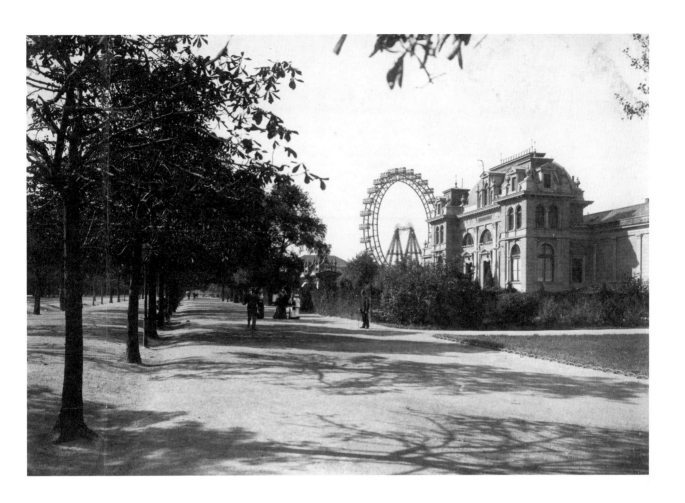

The Vivarium on Prater Hauptallee, ca. 1900

Photo: unknown, Wien Museum, inv. no. 229507

An aquarium opened on Prater Hauptallee in 1873. Created on the occasion of the Vienna World's Fair, it was renamed the "Vivarium" in 1888. The facility was based on international models. It displayed fresh and saltwater animals, seals, turtles, and crocodiles in large aquariums powered by steam engines. The Vivarium went bankrupt in 1902. At that point, it was acquired by zoologist Hans Leo Przibram (1874–1944) who turned it into the "Institute for Experimental Biology." Internationally renowned, the institute was also exceptional for the large number of women who conducted research there. It was not to last. Przibram's Jewish background occasioned frequent anti-Semitic attacks, and following Austria's annexation by Nazi Germany in 1938, the institute was closed. Przibram was murdered in the concentration camp Theresienstadt in 1944.

Dragon on the roof of the
Prater attraction "Elemental
Power of the Giants," 2020
Photo: Tom Koch

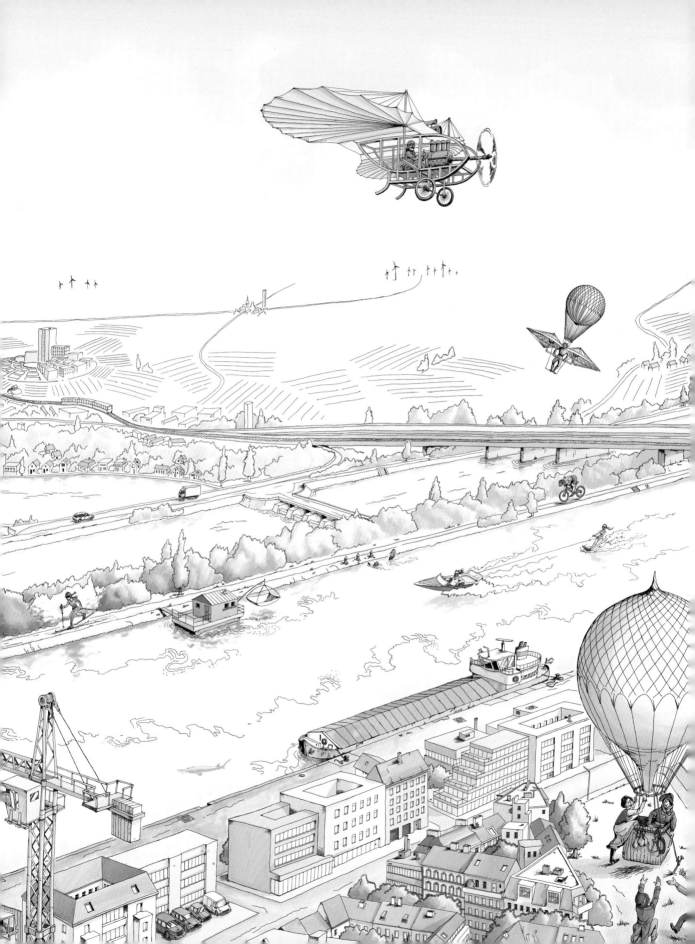

Technology

In the 19th century, huge engineering projects such as railroad construction, the regulation of the Danube, and the Vienna World's Fair brought the Prater closer to the city. Large-scale exhibitions showcased the latest achievements of the age such as steam engines, electric motors, the world's first wind turbine, tethered hot-air balloons, airplanes, bicycles, and cars. These also soon formed part of the attractions, featuring on merry-go-rounds, swings, and other rides. In its day, the Rotunda, the central building of the 1873 Vienna World's Fair, was the largest domed structure in the world, with a diameter of 350 ft. It could hold tens of thousands of people. The Riesenrad Ferris wheel was built in 1897, just four years after the first of its kind at the World's Fair in Chicago.

Prater Panorama 2024 by Olaf Osten (detail)
The *Praterspatz*, a motorized airplane, was built in 1907 on the grounds of the Rotunda by Austrian aviation pioneer and pilot Igo Etrich. Almost exactly a century earlier, in 1808, Swiss-born watchmaker Jakob Degen had taken off from the Prater in his flying machine. He steers the balloon using the two wings. The first woman to undertake a balloon flight in Vienna was Wilhelmine Reichard from Germany. In July and August 1820, she launched from Fireworks Square in the Prater and landed at the Belvedere Palace.
The "Seestadt Aspern" is visible in the background. Due to be completed in the 2030s, this entirely new city district will be home to some 25,000 people. The many branches of the Danube near Vienna were regulated between 1870 and 1875 in order to protect the city from flooding and secure shipping routes, creating a straight channel. In the 1970s, a second channel was dug, resulting in the 13-mile-long Danube Island, a recreational area popular with the Viennese.

For many people, their first encounter with an elevator or an escalator was at the Wurstelprater. Here they could get used to modern urban living—with its speed, noise, crowdedness, and rules—in spectacular and enjoyable ways. Technology was put on display for public education—but was also ironically commented on.

The latest construction techniques and materials were used to create fantastical experiences in the Prater. Especially spectacular was the *Venice in Vienna* theme park where, in 1895, Venetian palaces were faithfully recreated on a meadow by the Wurstelprater (today the Kaiserwiese), and where gondolas imported specially from Venice glided along artificial canals. This was an age when an imitation created using the latest technology was admired as much as the original. As a predecessor of the modern theme park, *Venice in Vienna* offered a cultural smorgasbord—Italian restaurants, Viennese coffee houses, Bavarian beer gardens, theaters, and operetta stages. Stores sold souvenirs and Italian handicrafts.

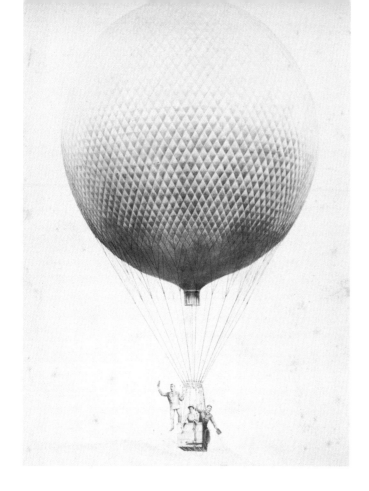

**In the basket of "Vindobona":
Victor Silberer with his wife Johanna
Silberer and the sports journalist
Georg Ernst, 1882**
Photo: Michael Frankenstein & Co,
Wien Museum, inv. no. 173115

Victor Silberer (1846–1924) was a
journalist, politician, and pioneer of
modern sport and Austrian aviation.
In 1882, he made his first ascent
in the Prater in the *Vindobona*, a
balloon purchased in France. Numer-
ous ascents for paying guests soon
followed. In 1888, he organized the
*International Exhibition of Airship
Aviation* in Vienna.

**Test flight by the Renner brothers
in the dirigible balloon "Estaric 1" in
the Prater in front of the Rotunda, 1909**
Photo: R. Lechner publishing house /
imperial and royal university book-
shop (Wilh. Müller), Wien Museum,
inv. no. 34017/6

The Renner family were performers
and circus folk from Graz. Father
Franz and his two sons, Alexander
and Anatol, were also pioneers of
Austrian aviation. In September
1909, they launched their dirigible
balloon, the *Estaric 1*, at the autumn
fair in Graz. In October they carried
out a test flight at the Krieau trotting
racecourse by the Rotunda.

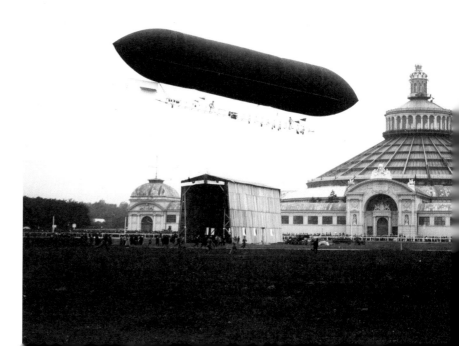

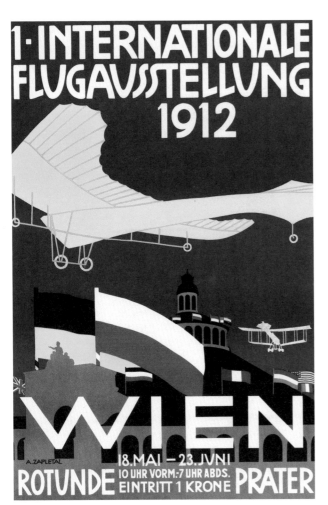

Poster "First International Air Show 1912"
Print: Alois Zapletal, Wien Museum, inv. no. 129118/1

The Rotunda was Vienna's principal site for the presentation of modern technology. Electricity (1883), airships (1888), automobiles (1897), and aviation (1912) were introduced to a broad public there. The building itself was an impressive monument to modern technology – with a span of over 350 ft, it was, in its time, the largest domed building in the world by far. That said, its sober iron construction was concealed by a historicist facade.

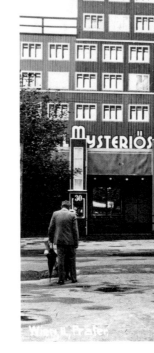

Postcard: Prater skyscraper "Hotel Mysterious," ca. 1933
Photo: unknown, Alexander Schatek (Pratertopothek), ID 0098811

A trail featuring illusions and tests of skill wound its way through the "Hotel Mysterious." The "Prater skyscraper" was built one year after the construction of Vienna's first high-rise building (Herrengasse). The windows were painted onto the facade and there was an organ above the entrance.

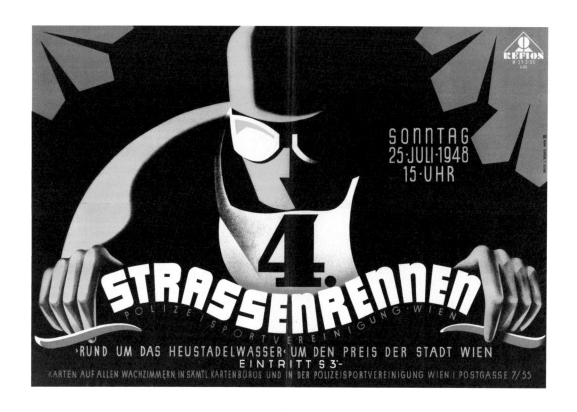

**Poster "4th Street Race of the
Police Sports Association—Around
the Heustadelwasser," July 25, 1948**
Print: J. Weiner, Wien Museum,
inv. no. 173387

**Poster "Vienna International
Automobile Exhibition" on the
Rotunda grounds, 1948**
Graphics: Hermann Kosel,
print: J. Weiner, Wien Museum,
inv. no. 173389

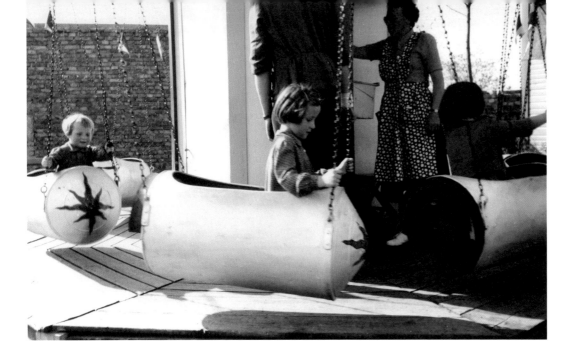

**Rocket merry-go-round
at the Prater, ca. 1960**
Photo: Leo Jahn-Dietrichstein
Wien Museum, inv. no. 228326

Go-kart track at the Prater, ca. 1960
Photo: Leo Jahn-Dietrichstein
Wien Museum, inv. no. 228270

Kids highway at the Prater, 2020
Photo: Tom Koch

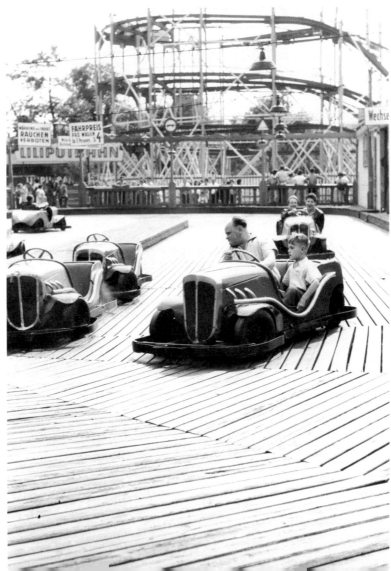

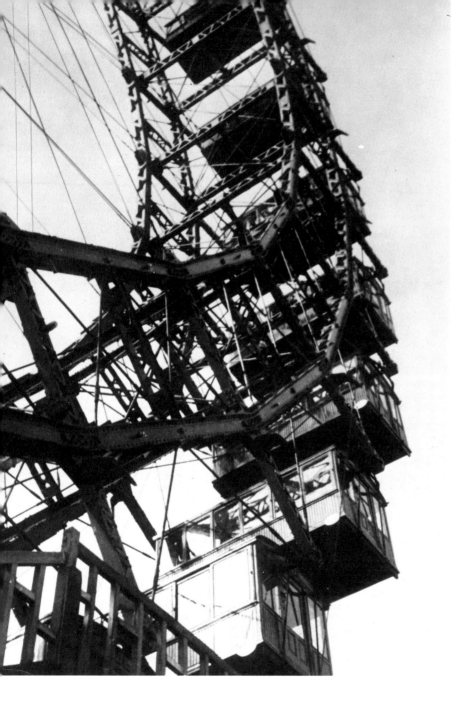

Riesenrad (detail), ca. 1930
Photo: unknown, Wien Museum,
inv. no. 54815

The Riesenrad, the Prater's giant
Ferris wheel, was erected in 1897.
It was the fourth such structure in
the world, the pioneering edifice
having been created by the American
engineer George Washington Gale
Ferris Jr. for the Chicago World's
Fair of 1893. Vienna's version, the
only one that survives from this early
period, was built by English engineers
Walter Bassett Basset (1864–1907)
and Harry Hitchins. Chief designer
was Hubert Cecil Booth. They created
the structure at the behest of Gabor
Steiner (1858–1944). The impresario
was looking for a new attraction for
Venice in Vienna. While the theme
park met its demise during World
War I, the Riesenrad endured, becom-
ing one of Vienna's biggest tourist
attractions. By 1938, its owner of
the Ferris wheel was Eduard Steiner
(no relation). He was murdered by
the Nazis in Auschwitz. In 1953, the
structure was restituted to his heirs.
Before World War II, the Riesenrad
sported 30 cabins. Ever since, it has
been half that number.

**Fan with colored lithograph
by August Reisser
as souvenir of "Venice
in Vienna," 1895**
Wien Museum,
inv. no. 174313

**"Venice in Vienna,"
from fold-out album: "Souvenir of
Venice in Vienna," ca. 1895**
Photo: Fritz Luckhardt, Wien Museum,
inv. no. 188581/6

Venice in Vienna was a theme park on today's Kaiserwiese, right next to the Prater's entrance. The attraction was created in 1895 by theater impresario Gabor Steiner (1858–1944). The plans came from architect Oskar Mamorek (1863–1909), who fitted an area of 500,000 ft² with Venetian palaces, piazzas, and canals. A trip to the real Venice had been the prerogative of the upper classes. With its artful fusion of technology and imagination, *Venice in Vienna* could be enjoyed by all. The theme park featured stores, restaurants, coffee houses, and numerous theaters. An initial sensation, the public's interest began to wane after two seasons. Steiner came up with something new: the Riesenrad, a giant Ferris wheel over 200 ft in height. Other attractions—an artificial lake, a massive slide, an elevated train—would follow.

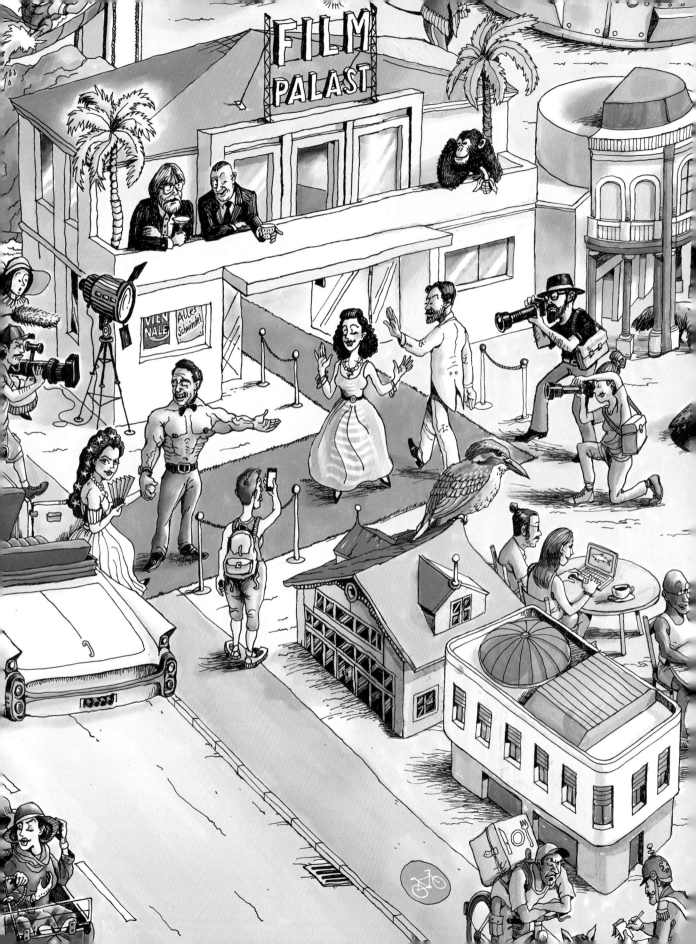

Movies

Vienna's first film screening took place in 1896. Shortly after this, the cinematograph—as the device for showing moving images was originally called—arrived in the Wurstelprater. During these early years, cinemas screened short films, travel images, scenes of nature and everyday life, and novelties of all kinds from around the world. With the advent of storytelling and the introduction of actors, cinema began its rapid rise to a modern form of mass entertainment.

From around 1905, movie theaters were among the largest and most commercially successful businesses in the Prater. After World War I, their number rose to seven, including the *Zirkus Busch Kino*. With 1,700 seats, it was the largest cinema in the city. All but one of the movie theaters—the Lustspielkino on Ausstellungsstrasse—were destroyed in the Prater fire at the end of World War II. After 1945, habits changed and the Wurstelprater gradually declined as an amusement and nightlife district in Vienna. Once again, it felt further away from the city, psychologically and culturally. It became a modern leisure park, visited above all by families with children. Cinema remained a popular form of entertainment, but its time in the Prater had passed.

Prater Panorama 2024 by Olaf Osten (detail)
Austrian film greats spanning more than a century of cinema share the red carpet: Romy Schneider as Sissi, Arnold Schwarzenegger as a strong man, Hollywood star Hedy Lamarr, and Oscarwinner Christoph Waltz. Having a chat on the balcony of the "Film Palast," formerly a theater and monkey show, are directors Michael Haneke (Oscar for *Amour* in 2013) and Erich von Strohheim. For his film *Merry-Go-Round* (1923) set in Vienna, Strohheim recreated the Prater in Hollywood.

Since the early days of cinema, the Prater has been a popular motif in Austrian and international films. "The Living Torso," Nikolaj Kobelkoff, for example, was showing off his skills on screen as far back as 1900. Viennese filmmakers such as Erich von Stroheim and Josef von Sternberg made the Prater a setting in US films. In *The Third Man* the view from the Riesenrad Ferris wheel over the Prater and the ruins of the city was chosen for its moment of truth. James Bond enjoyed himself here while being watched by the bad guys. And amidst the hustle and bustle, Ulrike Ottinger brought to light the more serious aspects of the Prater's history, including racism, in her 2007 documentary.

Austrian cinema populated the Prater with gallant gentlemen, villainous seducers, bon vivants, outcasts, braggarts, swindlers, pimps, and crooks. Joy and disappointment, love and betrayal, sex and violence are never far apart, whether in the bittersweet romances of the interwar years, like *Little Veronica* (Robert Land, 1929) and *Today Is the Most Beautiful Day of My Life* (Richard Oswald, 1936), or in the raw comedies and dramas made after 1945, such as *Women from Vienna – Scream for Love* (Kurt Steinwendner, 1952), *Exit... But Don't Panic* (Franz Novotny, 1980), the episode *Tagada* from *Slidin'—Shrill, Bright World* (Barbara Albert, 1998), and *Wild Mouse* (Josef Hader, 2017).

With *P.R.A.T.E.R.* by Ernst Schmidt Jr. (1963), even the artistic avant-garde came to the Prater, stripping it down to its basic elements: movement, light, voices, and sounds.

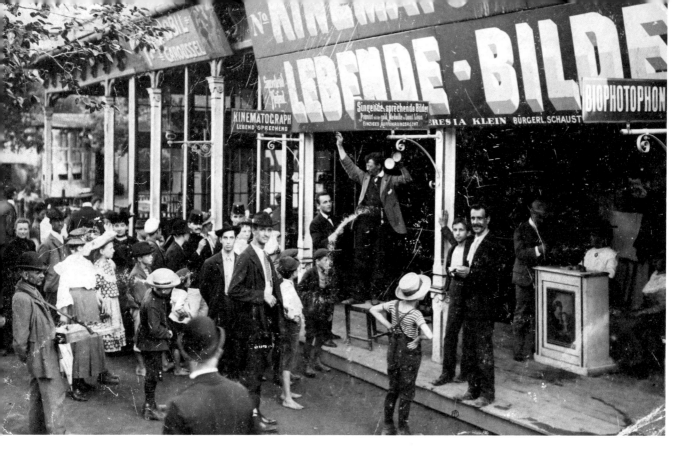

"Cinematograph Living Images"
by Theresia Klein, ca. 1905
Photo: unknown, Wien Museum,
inv. no. 215072

This unusual photo shows how movie
theaters took hold in the Prater. Huge
letters advertise the new attraction on
the building's facade, while a barker
extols it to the public, gesticulating
wildly. The owner, Theresia Klein, can
be seen behind the ticket booth in the
dimly-lit porch.

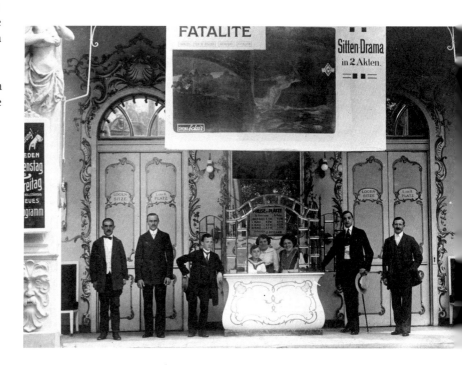

Stiller Cinema: probably the owner
Josefine Kirbes behind the cash
register with her employees
(with poster advertising the film
"FATALITÉ," F 1912), 1912
Photo: unknown, Wien Museum,
inv. no. HP 16/77/1

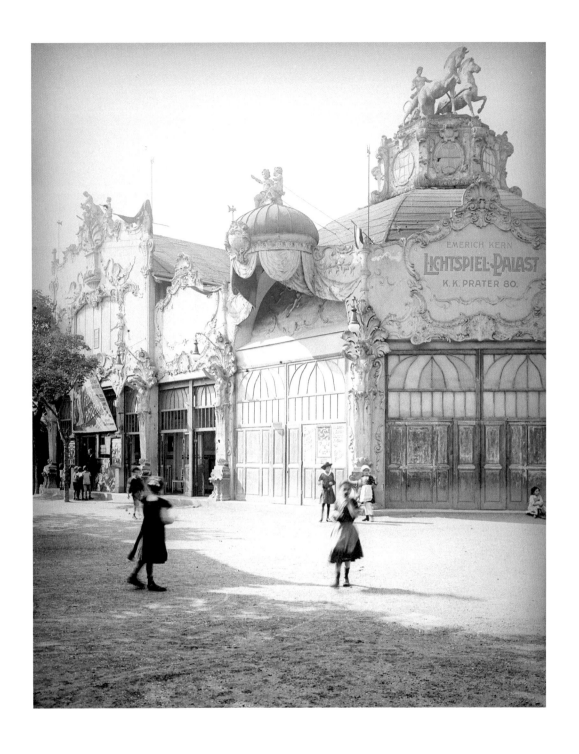

Lichtspiel-Palast cinema run by
Emerich Kern, ca. 1910
Photo: unknown, Austrian National Library,
Picture Archives, inv. no . 5209B POR MAG

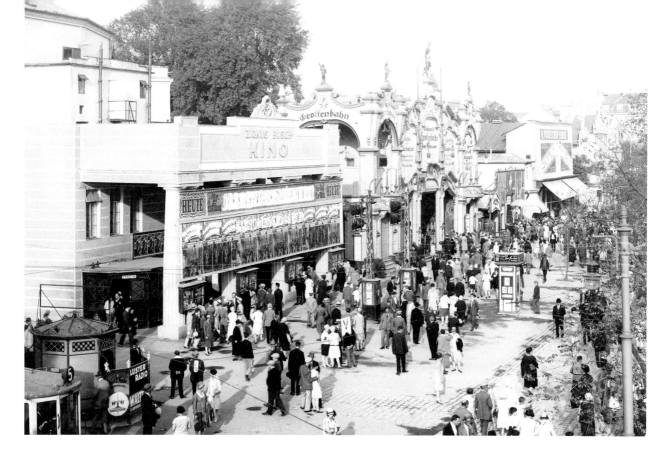

**Zirkus Busch Cinema
(front left) at the beginning of
Ausstellungstrasse, ca. 1930**
Photo: unknown, Austrian National
Library, Picture Archives,
inv. no. L 31.163c POR MAG

Lustspieltheater Cinema, ca. 1930
Photo: Alpenland, Wien Museum,
inv. no. 106692/2

**Frames from Friedrich Kuplents
"Prater" (1929)**
Austrian Film Museum

Friedrich Kuplent (1905–1985) was
an amateur filmmaker from Vienna
whose movie *Prater* (1929) made him
a pioneer of Austrian experimental
film. Using wild cuts, oblique per-
spectives, and cross-fades, Kuplent
focused on the Prater as a place that
was always in motion.

Poster for the documentary "Prater"
by Ulrike Ottinger, 2007
Graphics: Christine Horn,
Thomas Esterer, Vienna City Library,
inv. no. P–366568

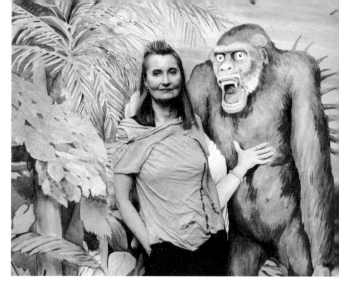

"Prater"—Elfriede Jelinek with Gorilla
Photo: Ulrike Ottinger, 2006; © Ulrike Ottinger

Austrian literature Nobel Prize winner Elfriede Jelinek features in Ulrike Ottinger's documentary film *Prater* (2007). She appears as a white woman who is abducted by a gorilla. This plays with the popular myth of King Kong, which is based on a 19th-century South African legend. A group of figures depicting this scene had also been on display in the famous *panopticum* operated by Hermann Präuscher.

Elfriede Jelinek wrote a text for Ulrike Ottinger's film in which she speaks about the temporary respite from the demands of the self: "By putting ourselves on show in these machines, whose only purpose is pleasure, by looking out from them at those standing nearby, who are looking at us, we hand over something of ourselves, we give it away, yes, by putting ourselves on display, we give ourselves away." (2006)

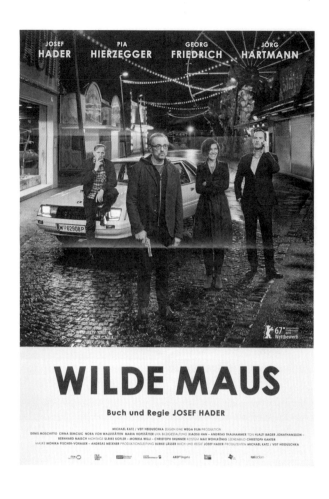

WILDE MAUS

Buch und Regie JOSEF HADER

MICHAEL KATZ / VEIT HEIDUSCHKA ZEIGEN EINE WEGA FILM PRODUKTION

DENIS MOSCHITTO CRINA SEMCIUC NORA VON WALDSTÄTTEN MARIA HOFSTÄTTER UVA BILDGESTALTUNG XIAOSU HAN – ANDREAS THALHAMMER TON HJALTI BAGER JONATHANSSON – BERNHARD MAISCH MONTAGE ULRIKE KOFLER – MONIKA WILLI – CHRISTOPH BRUNNER KOSTÜM MAX WOHLKÖNIG SZENENBILD CHRISTOPH KANTER MASKE MONIKA FISCHER-VORAUER – ANDREAS MEIXNER PRODUKTIONSLEITUNG ULRIKE LÄSSER BUCH UND REGIE JOSEF HADER PRODUZENTEN MICHAEL KATZ / VEIT HEIDUSCHKA

**Poster for the feature film
"Wild Mouse" by Josef Hader, 2017**
Vienna City Library, inv. no. P-246609
In the tragicomedy *Wild Mouse*,
a music critic who has lost his job
finds refuge in the Prater.

**Frames from Ernst Schmidt Jr.
"P.R.A.T.E.R." (1963)**
Sixpackfilm
In *P.R.A.T.E.R.* (1963), experimental
filmmaker Ernst Schmidt Jr. sets
everything in motion and underlays
this with a soundtrack of noises,
music, fragments of interviews, and
Ernst Jandl's sound poems.

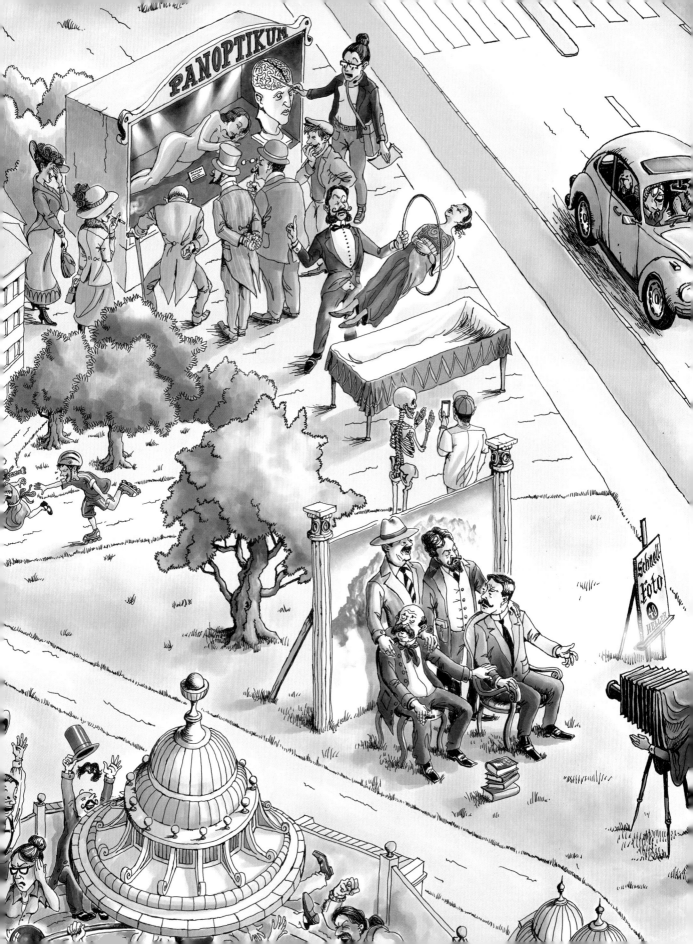

Body and Desire

The human body has formed part of the history of the Prater in a variety of ways. There have been ideal bodies, seemingly abnormal bodies, fantastical bodies, high performance bodies, and foreign bodies. Starting in the 19th century, anatomical museums with their wax specimens provided a way of seeing inside a person, of looking at the naked or diseased body. For the first time, public sex education was taking place outside medical schools—and was regarded with suspicion by the Catholic Church.

People with disabilities or physical anomalies were put on show as fairground attractions. For them, the Prater was an ambivalent place. They were brutally exposed to public curiosity, but could also find shelter, community, and a livelihood here. In particularly drastic cases, people were put on display in preserved form after their death. This happened to Julia Pastrana (1834–1860), who had hypertrichosis (excessive hair growth). Nikolaj Kobelkoff (1851–1933), on the other hand, who was born without arms or legs, became a successful businessman and established a Prater dynasty, which still exists today.

Prater Panorama 2024 by Olaf Osten (detail)
Until 1945, part of the Wurstelprater lay to the left of Ausstellungsstrasse in the Venediger Au park. Famous attractions were found here: *Präuscher's Panopticum and Anatomical Museum*, Kratky-Bashik's magic theater, and Karl Pretscher's grotto train and fairground photo studio, where souvenir photos were quick and cheap, and where photography became a mass medium. At the studio are four famous Viennese writers who, around 1900, were writing stories set in the Prater: Stefan Zweig, Arthur Schnitzler (standing), Peter Altenberg, and Hugo von Hofmannsthal (seated).

People from the European colonies, from Africa and Asia, were brought to Vienna to be put on show. They were exposed to sexist and racist violence. In the Rotunda, a huge round building, Hamburg animal trainer Carl Hagenbeck put on these kinds of presentations and preached Europe's technological superiority. Around 1900, the "Wiener Thiergarten am Schüttel" zoo featured African "villages," where members of the public could watch seemingly authentic presentations of daily life in places a long way from European "civilization." Virtually round the clock, the "villagers"—women, children, and men—were exposed to the intrusive gaze of the visitors, and subjected to a feverish interest in their bodies.

The Prater was the place where the limits and capabilities of the human body were put to the test, whether in feats of artistry, as tightrope walkers and trapeze artists, or as fire eaters and sword swallowers.

With their "strong men" and some "strong women," along with boxing, wrestling, and weightlifting, the Prater's venues popularized a new, athleticized physical ideal. Modern mass sport also took its first steps here, in the form of running, cycling, athletics, soccer, and tennis.

Many attractions continue to trade on extreme bodily experiences—on vertigo, shock, and panic. They provide psychological thrills and bodily excesses of a kind seldom permitted elsewhere in modern urban life.

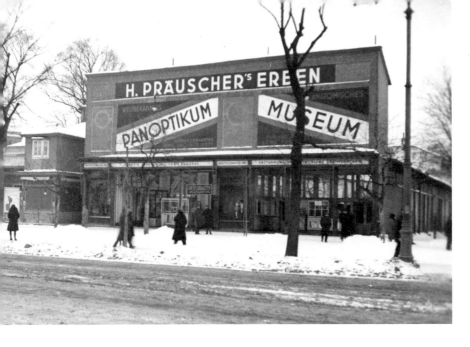

Facade of "H. Präuscher's heirs" on Exhibition street, "Panopticum" on the left, "Anatomical Museum" on the right, 1933
Photo: unknown, Wien Museum, inv. no. HP 16/140/21

Male torso with open back and intestines, ca. 1900
Wax, Wien Museum, inv. no. 169956/3

The wax figure was originally made for *Präuscher's Panopticum and Anatomical Museum*, which set up shop in 1871 on Ausstellungsstrasse in Vienna's Prater. Prior to this, Hermann Präuscher, who came from a family of showpeople, had toured Europe with his *Anatomical Museum*. Museums of this kind were popular attractions from the middle of the 19th century. They displayed anatomical and pathological specimens (created from real human parts or wax) and, following in the tradition of the medical collection, made the body and its diseases known to a wide audience for the first time. This often brought it into conflict with the Catholic Church.

In addition to the museum, a panopticon featured wax figures of famous people as well as scenes and events from history. This included crowned heads of state, sparring gladiators, the participants of Austria's 1872 polar expedition, figures from mythology, legends, and fairy tales, and famous criminals. What Präuscher offered was therefore part enlightenment, part horror, and part erotic thrill.

Präuscher's Panopticum and Anatomical Museum fell victim to the Prater fire of 1945. Only a few figures were saved. In the 1990s, some went on display as part of a *Sex Museum* in the Prater.

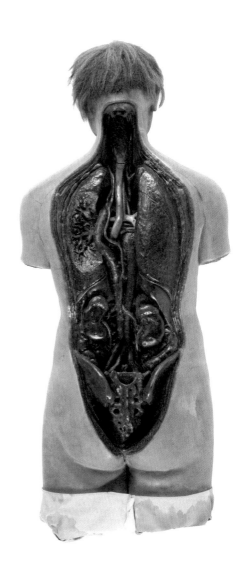

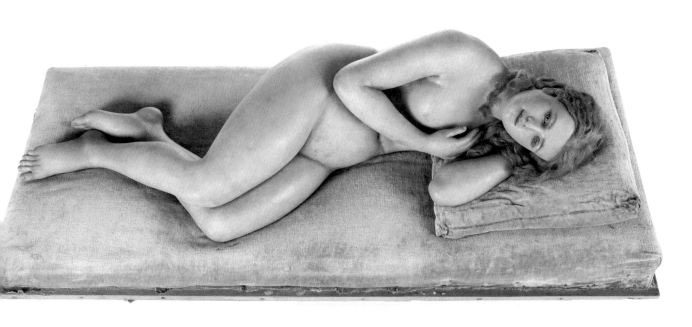

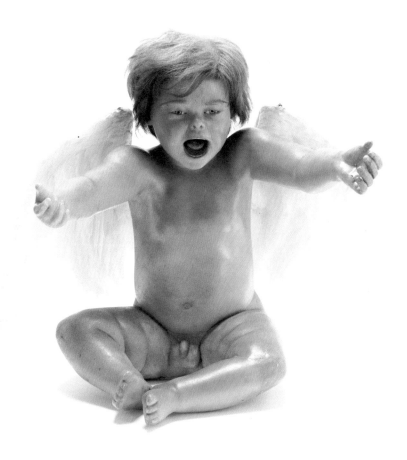

**"Resting girl" from
"Präuscher's Panopticum and
Anatomical Museum," ca. 1900**
Wax, Wien Museum, inv. no. 169956/2

**"Weeping Cupid" from
"Präuscher's Panopticum and
Anatomical Museum," ca. 1900**
Wax, Wien Museum, inv. no. 169956/1
Cupid, the personification of love,
weeps over a broken arrow, having
missed a heart he was aiming for.

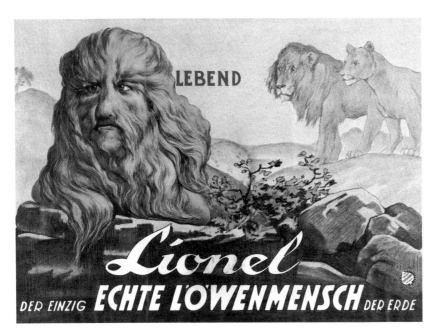

Born in Russia (now Poland), Stephan
Bibrowsky (1890–1932/34) had
hypertrichosis and was exhibited as
a "lion man" or "hair man" as a child.
He lived in Vienna from 1908 to
about 1910. For people with physical
anomalies, places like the Prater
were ambivalent. Here they were
often brutally exposed to the public's
curiosity, but they could also find
shelter, community, and a livelihood.
In particularly drastic cases, people
were put on display in preserved form
even after their death. This happened
to Julia Pastrana (1834–1860), who
also had hypertrichosis.

At Jakob Feigl's attraction, over the decades people with
special physical characteristics were put on display. Some
conditions were congenital while others were acquired
features, such as tattoos. And much was simply invented,
trading on the public's thirst for horror.

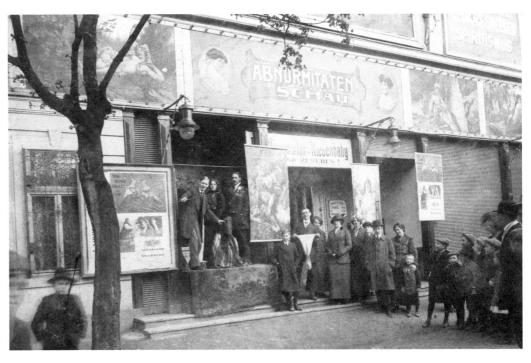

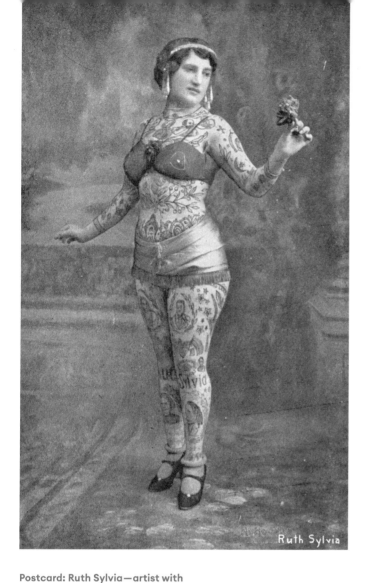

Postcard: Ruth Sylvia—artist with full body tattoos, ca. 1920
Photo: unknown, Wien Museum, inv. no. 221990/78

Ruth Sylvia, born in 1886 into a Viennese family of performers, started to display her full-body tattoos in the 1900s. According to newspaper reports, she had been tattooed by a Japanese woman in London.

The athlete "Wary" in Roman clothing at Circus Zentral in the Prater, 1923/24
Photo: unknown, Wien Museum, inv. no. 172921/22

A female wrestler during training, ca. 1900
Photo: Josef Fibinger,
Wien Museum, inv. no. 175702
Around 1900, wrestling matches between women were a common attraction at circuses and vaudevilles.

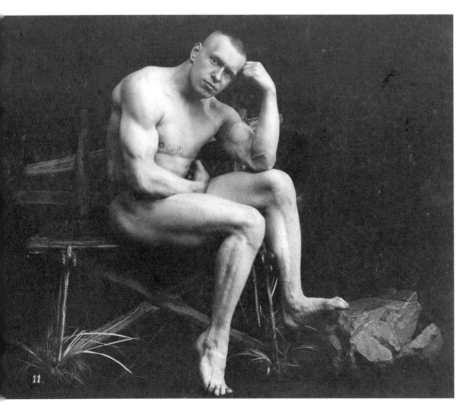

The wrestler and athlete Georg Hackenschmidt, 1904/1905
Photo: Wilhelm Scharmann,
Wien Museum, inv. no. 175708
In the course of the 19th century, the muscular male body became increasingly idealized. At first, there was no clear distinction between sideshow performances and organized athletics. "Strong men," often dubbed Hercules or Samson, performed in circuses and other places of amusement, but were also co-founders of the soon-to-be Olympic sports of wrestling and weightlifting. Georg Hackenschmidt (1878–1968), a Russian wrestler of German-Baltic origin, stayed in Vienna for extended periods of time, becoming European heavyweight champion in 1898.

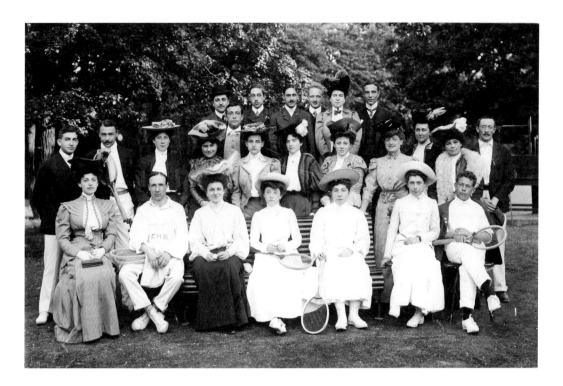

**Group photo from a tennis tournament
at the "Wiener Park Club," 1905**
Photo: R. Lechner publishing house / imperial
and royal university bookshop (Wilh. Müller),
Wien Museum, inv. no. MF 6872

The "Wiener Park Club" in Rustenschacherallee in the
Prater was founded in 1881 as a cycling club by members
of the imperial family, among others. Later, the Park
Club transformed into a tennis club. For several decades,
Davis Cup matches were held here.

Poster "Five Countries Competition," 1926
Publisher: Franz Adametz, Vienna City Library,
Poster Department, P-41304

The Five Countries Competition between Czechoslovakia,
Germany, Yugoslavia, Hungary, and Austria was held at the
Vienna Athletic Sports Club (WAC). Its facilities on Rusten-
schacherallee in the Prater had opened in 1898, featuring
tennis courts, track and field facilities, and a soccer pitch.

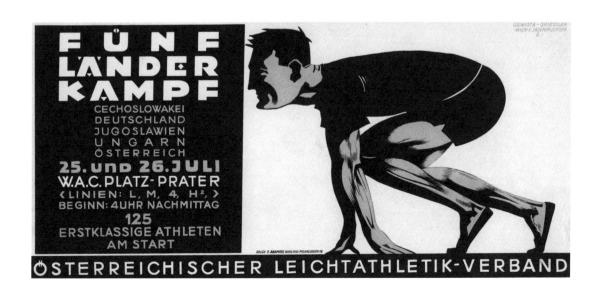

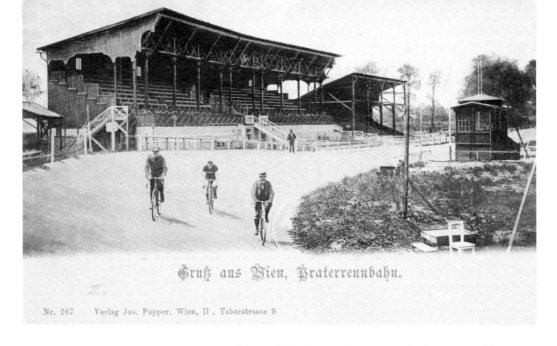

Gruß aus Wien, Praterrennbahn.

Nr. 267 Verlag Jos. Popper, Wien, II , Taborstrasse 9

Postcard: The first cycling track at the Prater, ca. 1900
Publisher: Jos. Popper, Wien Museum, inv. no. 234035
When the first bicycles appeared in 1860s Vienna, the Prater quickly became a popular place for cycling. The first formal bicycle paths were created there and, in 1885, four clubs banded together to build Vienna's first cycling track at the Prater. Friedrich Maurer was the winner of the first formal race, held in 1870. In the 1890s, Crescentia Flendrovsky (1872–1900) became one of the pioneers of women's racing.

Postcard: Prater Stadium, 1930s
Photo: unknown, Wien Museum,
inv. no. HP 27/10/4
The Prater Stadium (known today as Ernst Happel Stadium) was built for the 1931 Workers' Olympics. The architect was Otto Ernst Schweitzer (1890–1965), who designed the stadium as a democratic space: a flat bowl without VIP boxes or other hierarchical features. The stadium was a highly political place from the very beginning. During the interwar period—known as "Red Vienna" on account of the Social Democratic reforms characterizing the era—it was the scene of mass festivals. These continued during totalitarian rule, both under the Austro-Fascists (1934–1938) and in the Nazi period (1938–1945). The Nazis also turned the stadium into a site of horrors. In September 1939, Jews were corralled here, subjected to "anthropological" measurements, and then deported to Buchenwald concentration camp.

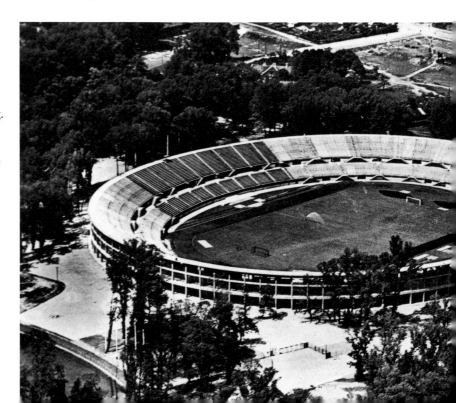

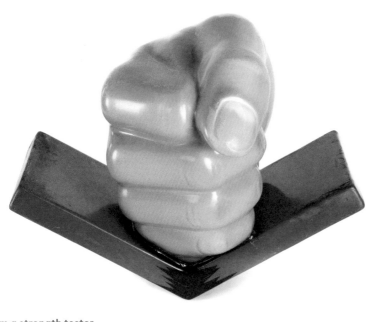

**Fist from a strength tester
at the Prater, 1980s/1990s**
Plastic, Gerhard Seifert
The fist punching through
a board was a decorative
detail from a strength testing
machine in the Prater.

**"Strong Man" from a strength
tester in the Prater, 1980s/1990s**
Plastic, Wien Museum, inv. no. SO 126
The "Strong Man" was part of a
strength testing machine in the
Prater. Players could pit themselves
against the figure in a tug of war.

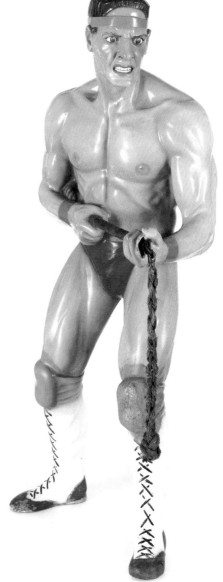

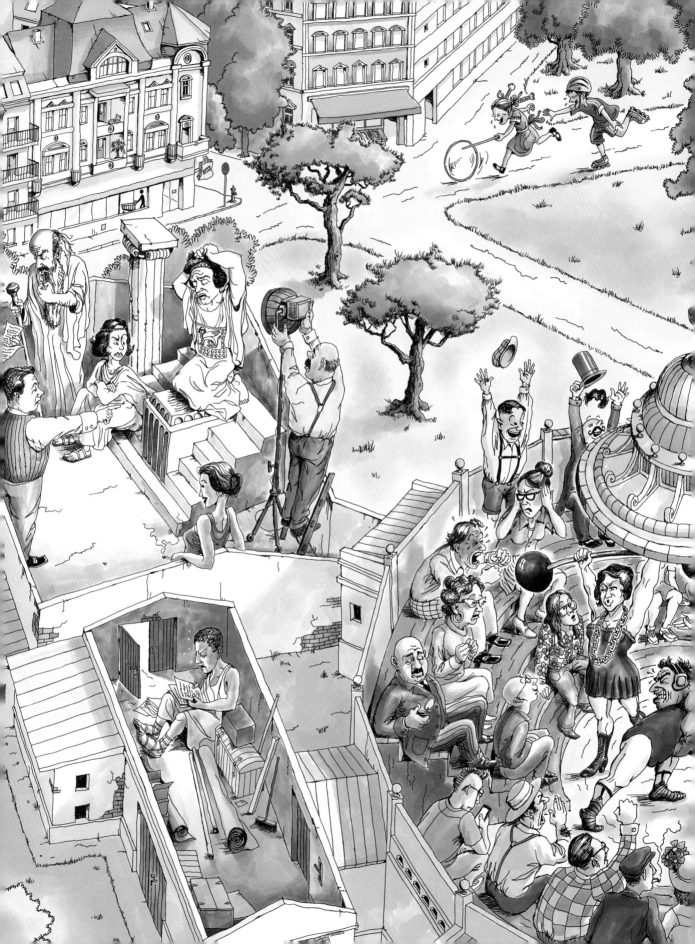

Grand Theater

Historically, the Prater was an important location for music and the dramatic arts with its many theaters, vaudevilles, cabarets, magic theaters, music halls, and circuses. Concerts took place in the salons and gardens of the restaurants and coffee houses. Ensembles, including famous women's orchestras, played marches, Viennese songs, and fashionable dance tunes—the popular music of the day.

Many playwrights chose the Prater as the setting for their works. In music, the Prater was and is a popular motif as the "Viennese location," used by composers from Mozart and Beethoven, Strauss, Lehár, Stolz, and Leopoldi, and into the present day.

Any evocation of the Prater, and especially the Wurstelprater, has always included its sounds—the rides and jukeboxes, human voices, barkers advertising their attractions, and the excited cries or frightened screams of the public.

The Prater gave anyone who wanted an opportunity to compete, be admired, and prove their skill, strength or courage—in the shooting gallery, against punching dummies and strength testing machines, on arcade games and pinball machines, at table football and air hockey, in the bumper cars, or on the go-kart track.

At the fairground photographer, visitors tried out other clothes and bodies, posing behind the wheel of a large car, steering an airplane, imitating and making fun of the rich and beautiful.

Art and spectacle were used in the Prater to convey current ideas about the world, both near and far, to huge audiences. This included panoramas, dioramas, grotto trains, and in particular the 1873 World's Fair, which put Vienna in the international spotlight for several months. Over 50,000 exhibitors from 35 countries showcased their latest inventions. The main focus was on machinery and industrial manufacturing. The site's architectural layout placed Vienna at the center of the world. In the main building, the Rotunda, Austria presented itself as a mediator between East and West, North and South, between industrialized and agrarian states. Japan used the Vienna World's Fair to introduce people to its culture and signal its readiness to open up to the West. Many countries such as Australia and India featured only as "appendages" to European colonial powers at this time. And heavily stereotyped images of the Orient shaped perceptions of countries from the Islamic world.

Prater Panorama 2024 by Olaf Osten (detail)
Austrian actor and director Max Reinhardt (top left) is rehearsing for his production of the Greek tragedy *Oedipus Rex*, which was performed in the Prater in 1911 in the huge, round *Circus Busch* building. Reinhardt wanted to use mass stagings to modernize and democratize theater. Playing the lead role of the tragic king Oedipus is Alexander Moissi, a famous stage actor of the day. *Circus Busch*, which opened in 1892 in a former panorama building, put on a range of attractions, including boxing and wrestling. Athletes are also among the acts. Converted into a movie theater in 1920, the building was destroyed towards the end of World War II in 1945.

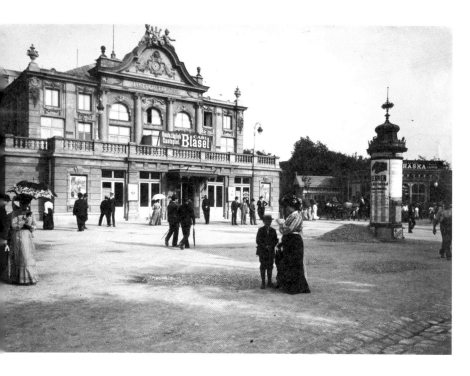

**Jantsch Theater (formerly
Fürst Theater), ca. 1900**
Buch- und Kunstverlag Gerlach &
Wiedling, Wien Museum,
inv. no. 135032/2/1

**Vienna Women's Orchestra in the
"Eisvogel" restaurant, ca. 1900**
Photo: unknown, Wien Museum,
inv. no. 72464
Women's orchestras made up entirely
or mostly of female musicians were
a popular attraction at the Prater's
restaurants and dance halls.

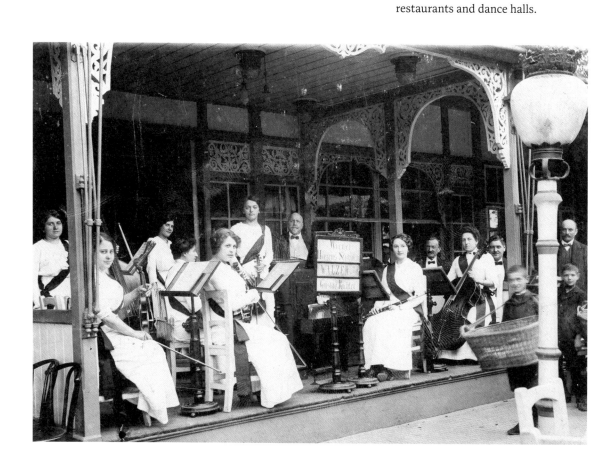

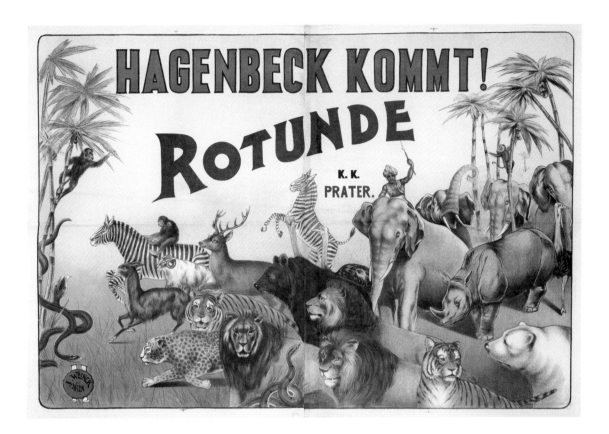

Poster "Hagenbeck is coming!," 1897
Print: J. Weiner, Albertina,
inv. no. DGNF 5457
Carl Hagenbeck (1844–1913) made
several visits to Vienna with his
animal shows and "human exhibits,"
always pitching his productions at
the intersection of spectacle and
scientificity.

Sheet music: Foxtrot song
"The Song of the Riesenrad," 1921
Music: Karl Hajós, lyrics: Beda
Publisher: Pierrot, Wien Museum,
inv. no. 172799

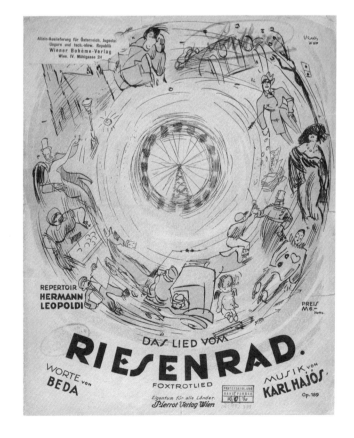

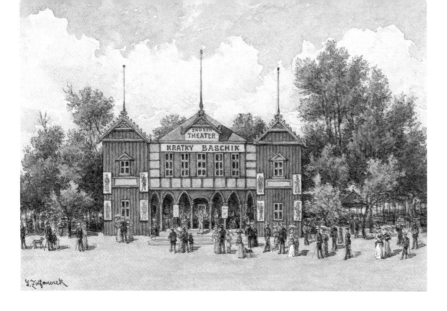

Gustav Zafaurek: Kratky-Baschik's
Magic Theater on Ausstellungsstrasse
in the Prater, 1879
Watercolor, Wien Museum,
inv. no. 24848

Anton Kratkz-Baschik with ghostly
apparitions, ca. 1880
Photo: unknown, Wien Museum,
inv. no. 239667/3

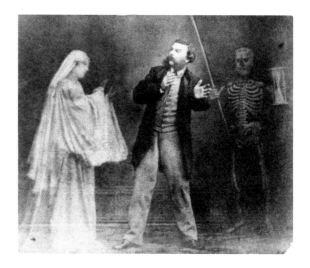

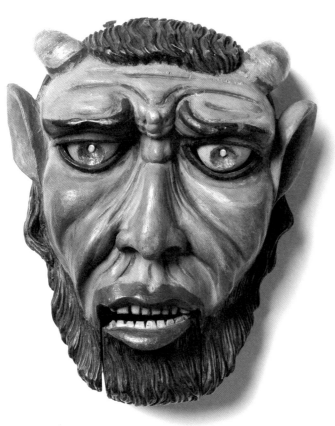

Devil's mask, likely from Anton Kratky-Baschik's
Magic Theater at the Prater, ca. 1900
Wien Museum, inv. no. 315528

Magician Anton Kratky-Baschik (1810–1889) was famous
for physical and optical illusions, often involving the
conjuring of ghostly apparitions on stage. In addition to
touring Europe and America, he owned a magic theater at
the Prater. Opened in 1874, it was kept in business by his
heir until 1911.

Punching dummy, after 1945
Leather and fabric,
Stefan Sittler-Koidl
Punching dummies, which first appeared at the Prater in the late 19th century, allowed visitors to test their strength in front of an audience or simply vent their anger. The human-sized figures had oversized heads and were struck with a kind of glove. A force gauge displayed the strength of the punch

Diorama with view of New York from the Liliputexpress at the Prater, 1958
Wood, Wien Museum, inv. no. 197146
The Liliputexpress was a miniature railway, which also took visitors past views of Paris, Moscow, and Venice.

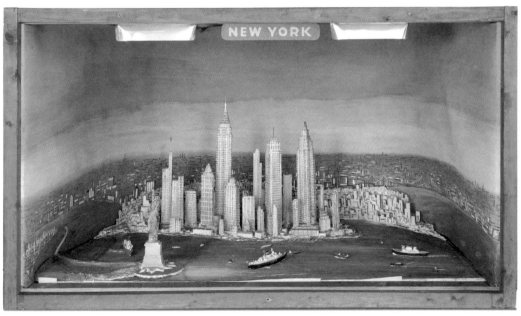

The Vienna World's Fair of 1873 on the Krieau in the Prater was the fifth world's fair, following two each in London and Paris. It was also the first to be held in the German-speaking world. Covering some 575 acres, it was five times larger than the previous fair in Paris. 35 countries and more than 50,000 exhibitors took part. Austria presented itself as a mediator between worlds, between industrialized and agrarian countries, between Occident and Orient. But many parts of the world were there only as European colonies. The World's Fair had been preceded by a huge modernization drive in Vienna, then one of the largest cities in the world. The Danube was regulated, six terminus railroad stations were completed, a horse-drawn railway represented a mode of modern mass transportation, and Vienna's first spring water pipeline brought fresh drinking water to Vienna from the mountains.

The World's Fair was overshadowed not only by the stock exchange crash and subsequent international financial crisis, but also by the outbreak of a cholera epidemic.

Main entrance to the World's Fair with the Rotunda in the background, 1873
Photo: György Klösz, Wien Museum, inv. no. 47869/31

György Klösz was one of the four photographers of the "Vienna Photographers' Association" with exclusive rights to document the fair. They had two pavilions on the fairgrounds and employed 50 women and men.

"Exhibition of Women's Work" in the "Additional Exhibition" pavilion, 1873
Photo: Michael Frankenstein & Comp.
Wien Museum, inv. no. 173701/45
Education played an important role at the Vienna World's Fair and the topic of women's work and education was introduced for the first time. One pavilion housed an exhibition developed in cooperation with women's employment associations.

Children's Pavilion, 1873
Photo: György Klösz, Wien Museum, inv. no. 173701/27
The "Children's Pavilion" extended the focus on education to early years, presenting equipment for "gymnastics of the senses," intended to train a child's sense of sight or smell.

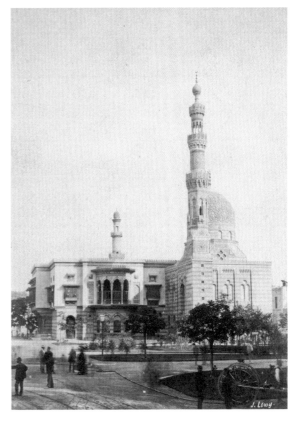

"Egyptian Building of the Khedive" (palace of the viceroy of Egypt), 1873
Photo: Josef Löwy, Wien Museum, inv. no. 174006/10
Egypt (still formally part of the Ottoman Empire) showcased itself at the Vienna World's Fair with an elaborate pavilion. Although the country was striving for economic and political reform along European lines, perceptions of it in Vienna were heavily shaped by Orientalist ideas.

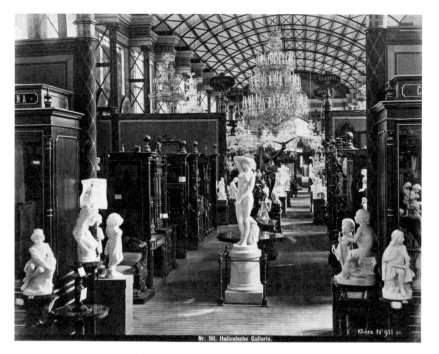

Nr. 911. Italienische Gallerie.

Klösz. Nº 911

Art gallery—the Italian section, 1873
Photo: György Klösz, Wien Museum, inv. no. 78080/191

Art gallery—the Japanese section, 1873
Photo: Josef Löwy, Wien Museum, inv. no. 174005/11

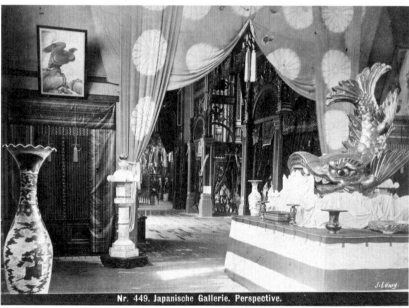

Nr. 449. Japanische Gallerie. Perspective.

J. Löwy.

Vincenz Estenfelder: Model of the 1873 Vienna World's Fair (detail), ca. 1880
Cardboard, Wien Museum, inv. no. 12788

The model was built by Vincenz Estenfelder (d. 1912), a Viennese cardboard packaging manufacturer. It was displayed in 1880 at the Lower Austrian Trades Exhibition in the group representing the paper industry and was praised in the press above all for its accuracy. Estenfelder based the model on plans and photographs, but likely also his own observations. The museum acquired the model from a private owner in 1896.

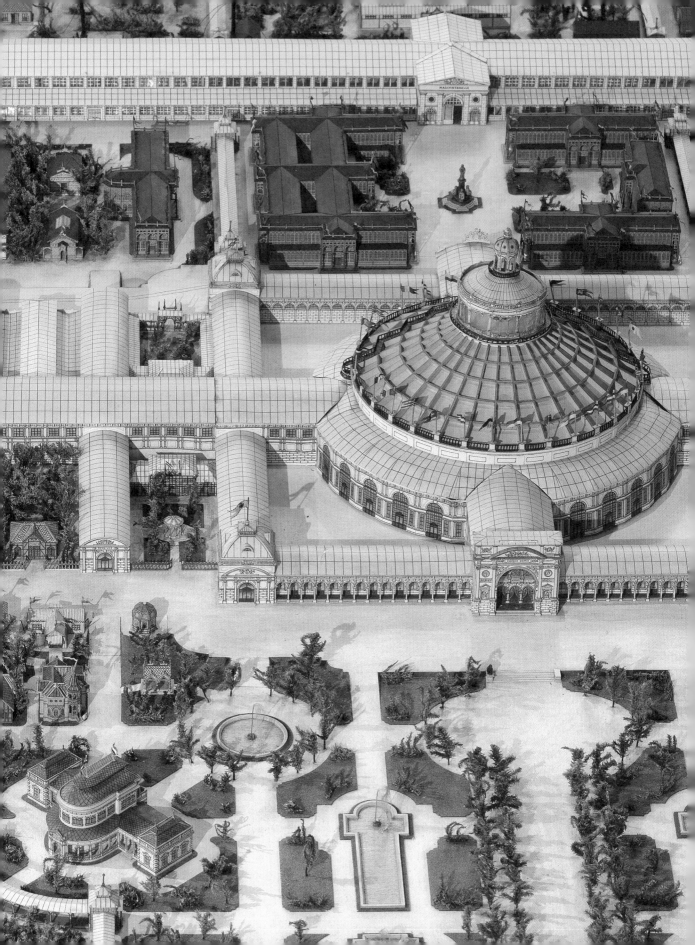

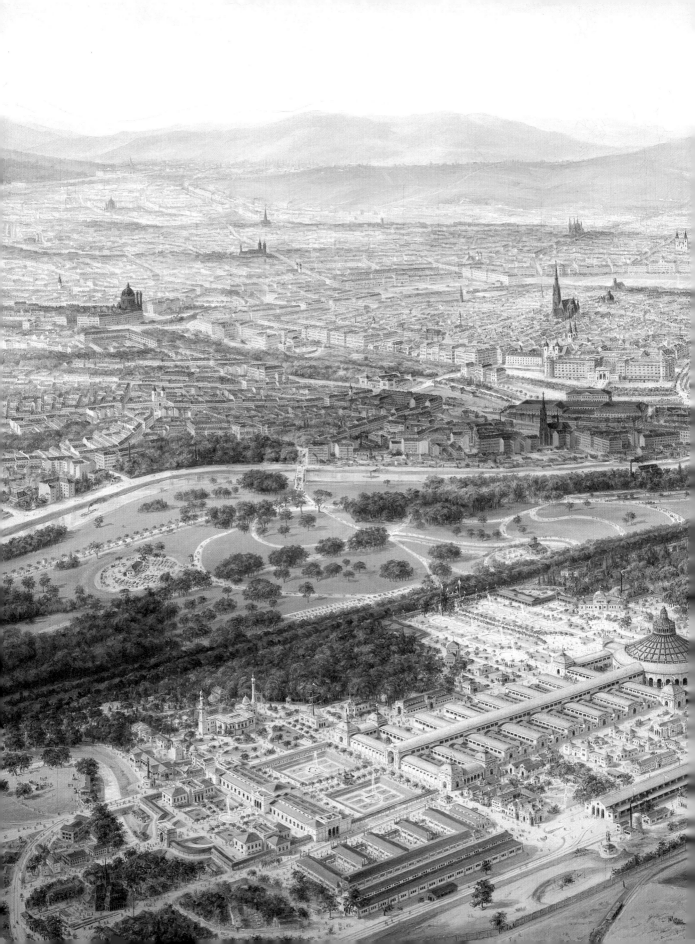

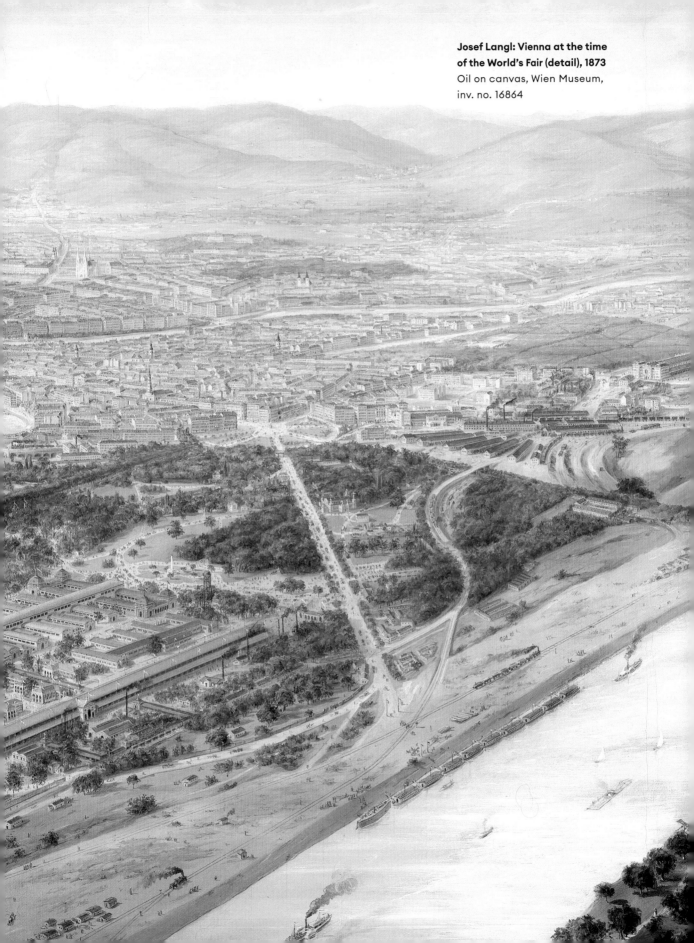

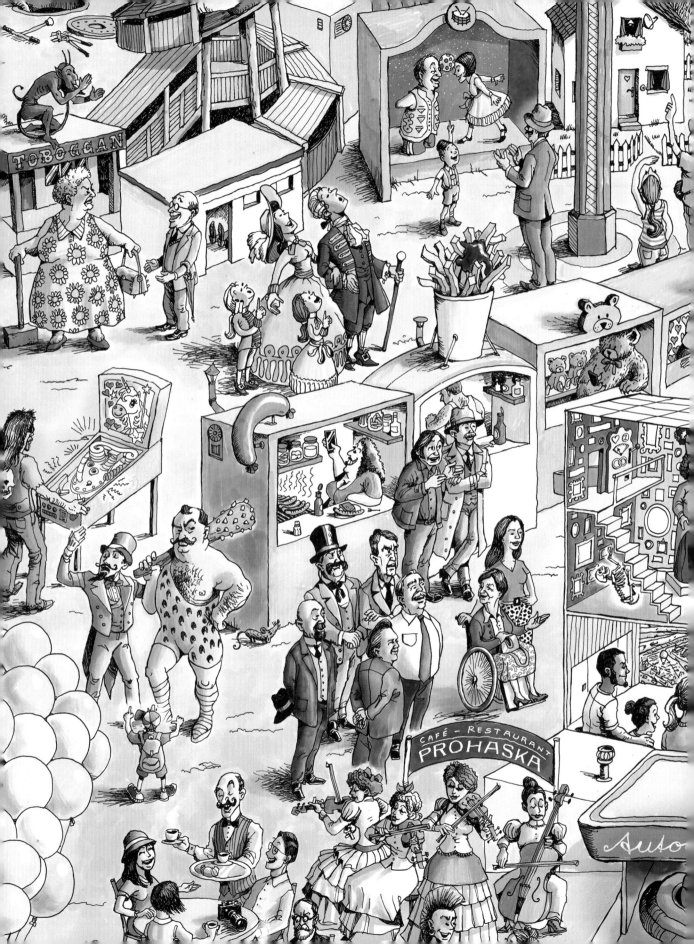

Hall of Fame

The first to move into the Prater after it opened to the public were inn and coffee house owners from the city. They provided refreshments for day-trippers from simple wooden huts surrounded by large gardens. Circus folk, performers, musicians, and showpeople soon followed. Usually, they did not stay long in the Prater and often toured Europe with their acts and attractions. The position they held in society was an ambivalent one: while they were entertaining and diverting, bringing novelties to Vienna from around the world, and firing people's imaginations, the authorities and Church viewed them with suspicion on moral grounds and for their often very persuasive way with words. Today we would consider them pioneers of modern advertising. Attractions could take almost any form, all that was needed was creativity, a sense of novelty, and courage. The arrival of modern amusement parks in the late 19th century brought changes to the showperson profession. Mechanical attractions became more popular, pushing out performance artists and circus acts. After 1945, they almost completely vanished.

Until the end of the monarchy, the Prater was the personal property of the emperor. Care was thus taken not to tarnish the monarch's reputation with unsuitable festivals, and all attractions, streets, and squares had to have respectable names.

Prater Panorama 2024 by Olaf Osten (detail)
From top to bottom: One Prater celebrity is "The Living Torso" Nikolaj Kobelkoff. Born in Russia, he came to Vienna in the 1870s, where he founded a dynasty of entrepreneurs. His descendants, Prater business owners Liselotte and Silvia Lang, can be seen next to Vienna's mayors (Ludwig, Seitz, Felder, Zilk, and Häupl).

In addition, the Wurstelprater and park areas in general were heavily monitored by the authorities. Yet the sheer size of the Prater created spaces outside their control. Today the Prater is owned by the City of Vienna, with land leased to the businesses in the Wurstelprater.

The Nazi era left a deep mark on the Prater. Jewish business owners were robbed of their property and driven out. This included the many branches of the Deutschberger family, who ran several long-standing taverns and owned shares in the Liliputbahn miniature railway. The owner of the Riesenrad Ferris wheel, Eduard Steiner, was murdered in Auschwitz in 1944. Among those who profited from this were Prater business owners, a number of whom were members of the Nazi Party. The new Nazi rulers, however, viewed the Prater—a place with a tradition of inclusivity and social equality—with contempt. But the Prater was also a place of resistance, especially for groups of young people like the Schlurfs who met there. With their long hair and love of US jazz music, they refused to conform to Nazi ideals. In the final weeks of World War II, the Wurstelprater was devastated by fire. Only the Riesenrad and a few other attractions survived the flames. Reconstruction began soon after the war, supported by the Allied administration.

Today, many of the businesses and attractions are owned by just a few families, often going back several generations. These are the "Prater dynasties" or, as they like to call themselves, the "Prater children."

Prater Businesspeople

Top left:
Carl Schaaf, showman, ca. 1930
Photo: unknown, Wien Museum,
inv. no. 172769/36

Top right:
**Juliana Holzdorfer, owner of the
"Ghost Castle," ca. 1940**
Photo: Albert Hilscher, Wien Museum,
inv. no. HP 16/96/20

Left:
**Basilio Calafati, owner of the "Great
Chinese Man" merry-go-round, 1862**
Photo: unknown, Wien Museum,
inv. no. 172393

OPPOSITE PAGE
Top left:
**Hermann Präuscher, owner of
"Präuscher's Panopticon," ca. 1885**
Photo: unknown, Wien Museum,
inv. no. 172769/16

Top right:
**Emma Willardt, showwoman
and owner of a rapid photography
studio, ca. 1880**
Photo: unknown, Wien Museum,
inv. no. HP 16/147/5

Bottom left:
**Gabor Steiner, founder of
"Venice in Vienna," ca. 1885**
Photo: unknown, Wien Museum,
inv. no. 172552

Bottom right:
**Anna Zwickl, proprietor
of the Lusthaus, 1892**
Photo: August Leutner,
Wien Museum, inv. no. 172338

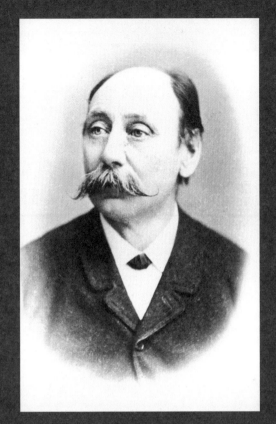
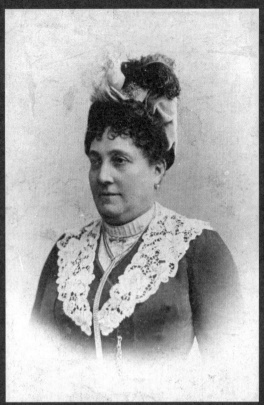

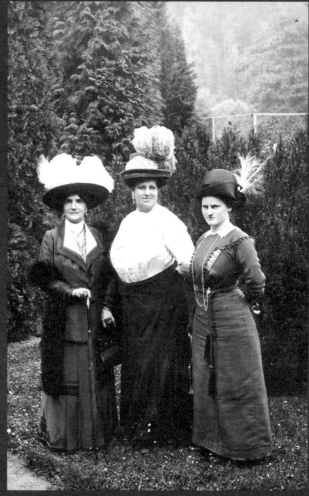

Top left:
Johann Griess with companion, proprietor of the "Golden Rose" tavern, ca. 1910
Photo: unknown, Wien Museum, inv. no. HP 16/65/6

Top right:
Theresia Klein, Philomene Marangoni, and a third woman, showwomen, ca. 1905
Photo: unknown, Wien Museum, inv. no. 16/40/40

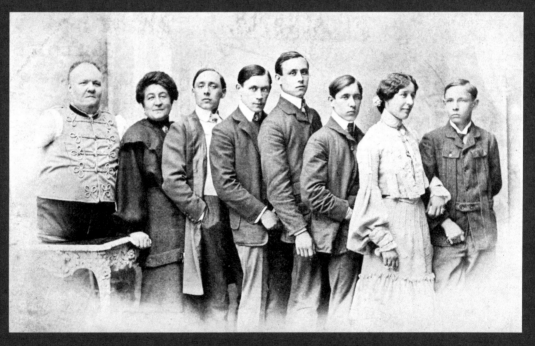

Top:
**Kolnhofer family,
showpeople, ca. 1948**
Photo: unknown, Thomas Sittler
(Pratertopothek), ID 0927400

Bottom:
**Kobelkoff family,
showpeople, ca. 1908**
Photo: unknown, Nikolaj Pasara
(Pratertopothek), ID 0259842

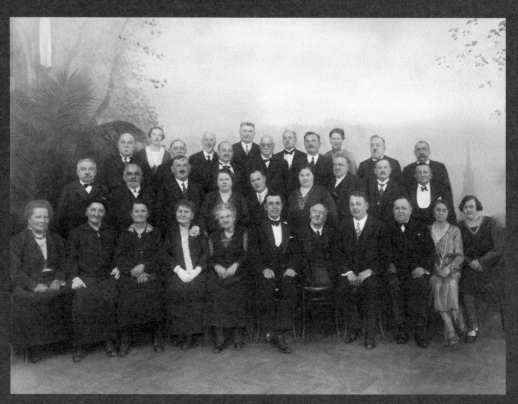

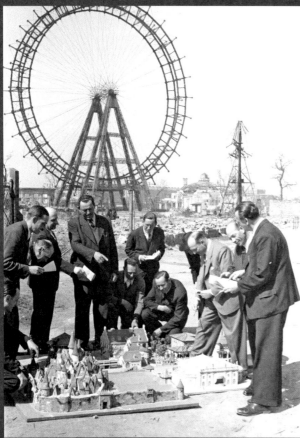

Association of Prater Attraction Owners, 1931
Photo: unknown, Wien Museum, inv. no. 175542

Prater business owners with a model of the Prater for reconstruction 1945
Photo: Otto Croy, Austrian National Library, Picture Archives, inv. no. CRO 511W POR MAG